DEAF WAY II
An International Celebration

Foreword by I. King Jordan

Editors **Harvey Goodstein, Laura Brown**
Photography Editor **Ralph Fernandez**
Designer **Zhou Fang**

Gallaudet University Press
Washington, D.C.

Contents

Marla Moffet

Allen Matthews

Marla Moffet

Veronique Smith

Rita Struabhaar

Young Park

Mitko Androv

Jennifer Hinger

Sung Park

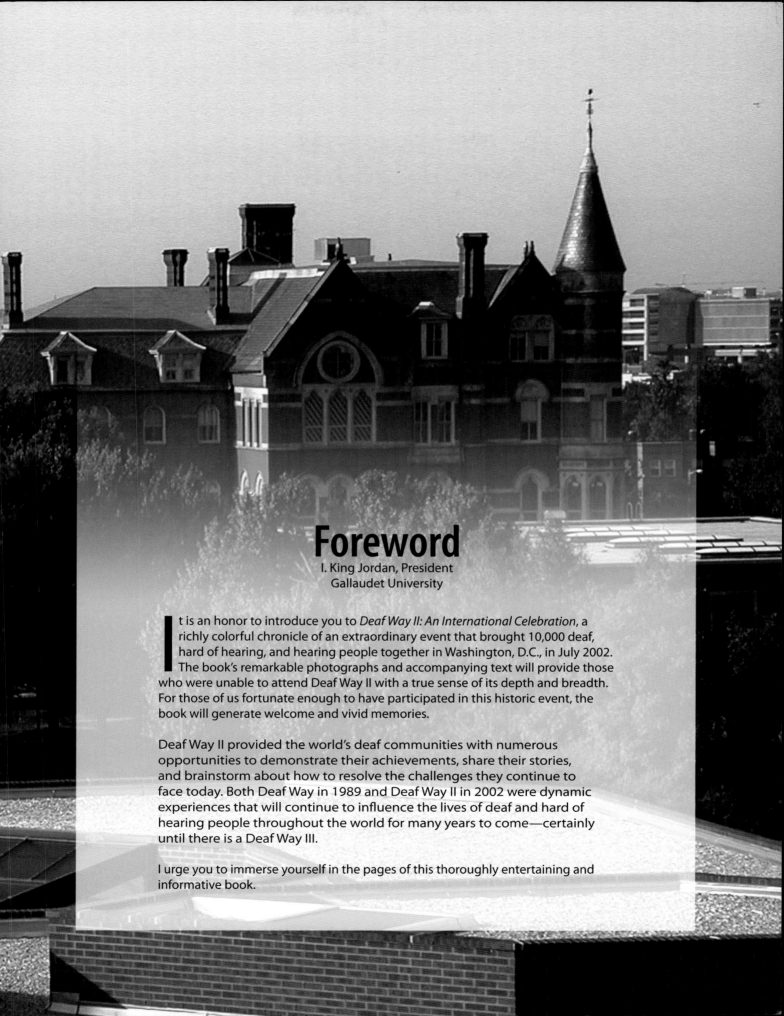

Foreword

I. King Jordan, President
Gallaudet University

I t is an honor to introduce you to *Deaf Way II: An International Celebration*, a richly colorful chronicle of an extraordinary event that brought 10,000 deaf, hard of hearing, and hearing people together in Washington, D.C., in July 2002. The book's remarkable photographs and accompanying text will provide those who were unable to attend Deaf Way II with a true sense of its depth and breadth. For those of us fortunate enough to have participated in this historic event, the book will generate welcome and vivid memories.

Deaf Way II provided the world's deaf communities with numerous opportunities to demonstrate their achievements, share their stories, and brainstorm about how to resolve the challenges they continue to face today. Both Deaf Way in 1989 and Deaf Way II in 2002 were dynamic experiences that will continue to influence the lives of deaf and hard of hearing people throughout the world for many years to come—certainly until there is a Deaf Way III.

I urge you to immerse yourself in the pages of this thoroughly entertaining and informative book.

Acknowledgments

The Deaf Way II conference and arts festival was an outstanding success. The first word of thanks goes to Gallaudet University for its tremendous support as the host of this large international event in Washington, D.C. Heartfelt thanks go to the partners and sponsors (listed in the appendix) who made it affordable and possible to carry on our activities at several off-campus venues in the metropolitan area, thereby making the event highly visible to a large audience of deaf, hard of hearing, and hearing people.

Our sincere appreciation goes to all the conference presenters and arts festival artists - and the participants - who graciously gave their time and effort in making the conference and arts festival programs highly educational, enriching, and memorable.

The proceeds of this book will go to a Gallaudet University scholarship fund for international students, which is made possible by the following sponsors:

- Gallaudet University

- Laurent Clerc Cultural Fund, Gallaudet University Alumni Association

- Macfadden and Associates, Inc.

- Hamilton Relay

We want to extend our special thanks to Ivey Wallace and Deirdre Mullervy of the Gallaudet University Press for their encouragement and expertise from the very beginning of this exciting book project, and for keeping us on track toward its completion.

Harvey Goodstein
Laura Brown
Ralph Fernandez
Zhou Fang

Welcoming the World

Deaf and hard of hearing people sign, speak, and write different languages. We are as geographically, religiously, economically, and ethnically diverse as the rest of the world. Yet one undeniable common experience unites us. During one week in July of 2002, nearly 9,700 people came to Washington, D.C., from all over the world to share that experience at Deaf Way II. The scholarly conference and cultural arts program offered a unique opportunity for attendees to explore the unity and diversity of deaf life while reflecting on the past and imagining the future for the world's Deaf community.

Like the original Deaf Way in 1989, Deaf Way II attracted thousands of people and provided them a place and time to analyze, debate, display, and enjoy the rich language, culture, history, and art of deaf and hard of hearing people from every corner of the globe. However, Deaf Way II had important differences and new challenges, reflected in the vision statement developed by the Organizing Committee. According to that statement, Deaf Way II's first objective was to "encourage cross-cultural and cross-continent exchanges." With 3,108 international participants —representing 121 countries and six continents— Deaf Way II definitely met that goal.

Even the Deaf Way II logo reflected the event's global character. Zhou Fang, an alumnus of Gallaudet University from China, designed the logo using the vision statement as inspiration. He recognized that many countries use similar handshapes for the letters "D" and "W" and the number "2." The three curved and brightly colored tips represent the letters and the number. The globe represents the world. Further, the colors chosen are found in the majority of national flags around the world.

This book brings the many wonderful and unique experiences of Deaf Way II to life through its photographs. As Jim Macfadden, a deaf business owner, eloquently stated, "The first Deaf Way was set thirteen years ago to show what deaf and hard of hearing people *can* do, but Deaf Way II showed the world what they *are* successfully doing now."

Deaf Way II will:

- Encourage cross-cultural and cross-continent exchanges through an international conference on language, culture, history, and art of deaf and hard of hearing people.

- Examine technology use by, for, and on deaf people and consider the interconnectedness of deaf, hard of hearing, and hearing people in an increasingly technologically sophisticated world.

- Celebrate the visual, performing, and literary arts of deaf and hard of hearing people through a Cultural Arts Festival.

- Foster greater tolerance and understanding among deaf, hard of hearing, and hearing people through scholarly discussions and experiential cultural events for participants, and extensive outreach to the general public.

- Heighten opportunities for deaf and hard of hearing people by bringing to light our artistic, leadership, and professional capabilities and diverse contributions to societies around the world.

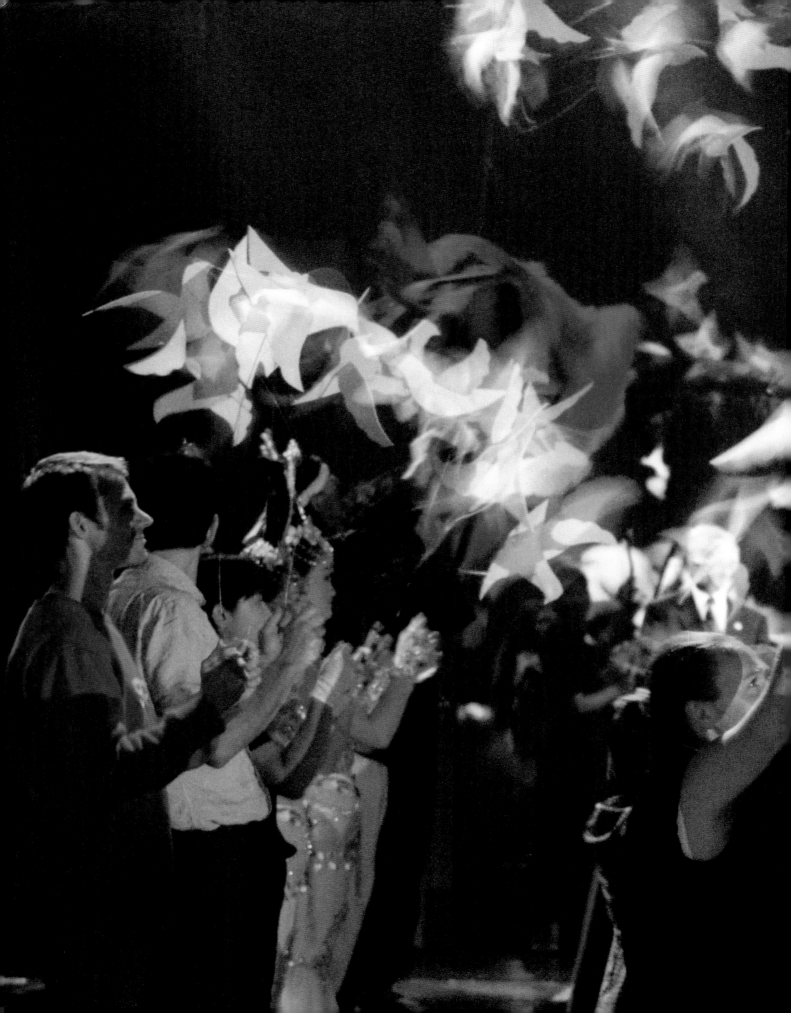

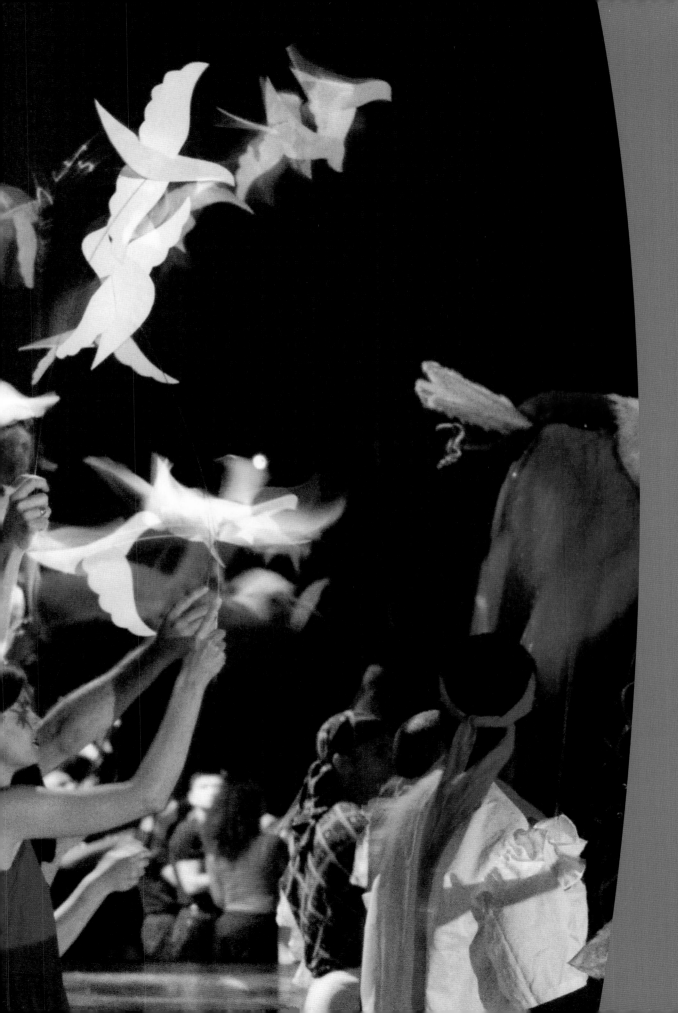

OPENING CELEBRATION

eaf Way II officially began on the evening of July 8, 2002, before a standing-room-only crowd in the 7,000-seat theater at the Washington Convention Center. Gallaudet University President I. King Jordan welcomed the audience to the Opening Celebration, a remarkable visual and musical production that gave the audience a taste of the speakers, presenters, and artists they would be seeing throughout the week-long conference and arts festival.

Producer Tim McCarty and director Iosif Schneiderman planned the Opening Celebration using strong visual elements and minimal amounts of signing and speaking so that the performance could be understood and enjoyed by the diverse, international audience. This two-hour production created a festive environment that audience members carried with them through the week. Some even compared it to a $5 million Las Vegas production!

Five large projection screens at the front of the theater, and two additional screens in the middle, made the entire show visible to everyone in the theater. Live-action and looped animation films flashed on the screens, welcoming the enthusiastic crowd. A group of deaf Native Americans offered a blessing by burning sweet grass, directing the rising smoke with an eagle feather, and then dancing to traditional drumming. Twelve-foot-tall rod bird puppets, designed and developed by

Gallaudet University students, entered the stage along with cast members waving bolts of fabric. The birds represented people flocking to Washington to participate in Deaf Way II. The fabric represented the diversity of attendees at Deaf Way II and paralleled the colors used on the Deaf Way II logo.

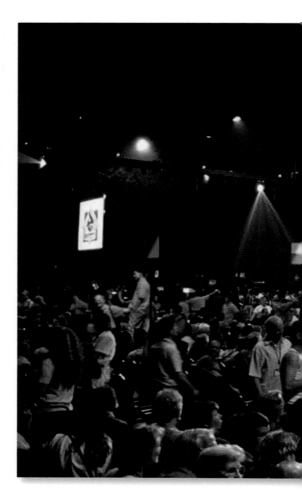

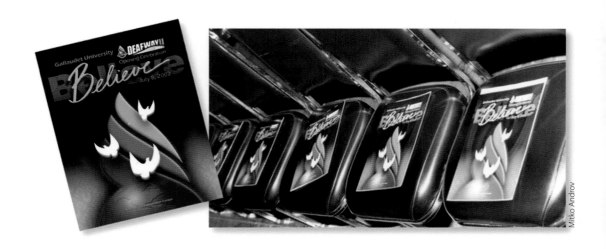

Mitko Androv

The "Bird Man," hilariously performed by Canadian mime artist Max Fomitchev, served as the host for the evening. He, along with a group of clowns and waving fabrics, kept the evening flowing nonstop between various performance groups and speeches. During the speeches, real-time captioning as well as American Sign

Filled with spectacular visual effects and an array of international performers, the Opening Celebration ushers in the week's festivities. Program books, above, detail the evening's festivities.

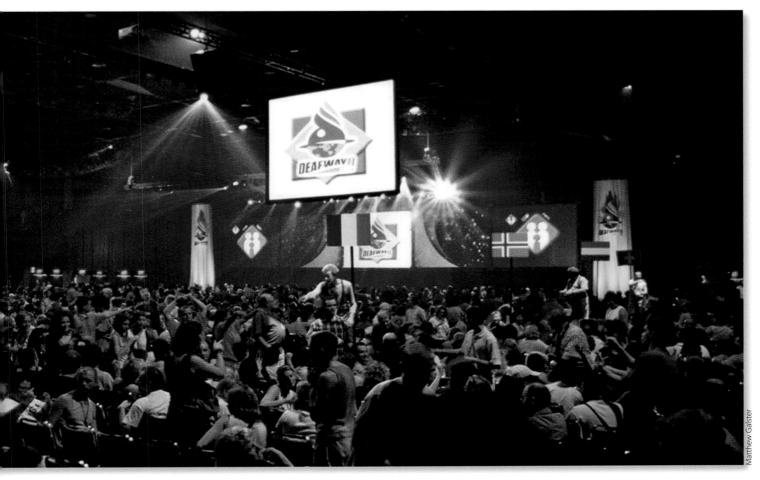

Matthew Galster

Language and International Sign interpreters were projected on the large screens. The sound equipment was so powerful that every deaf and hearing person in the audience was able to feel or hear the musical accompaniment to the performances.

The title for the Opening Celebration was *Believe*, and it was brought to life with the selection of "When You Believe," from the animated film *The Prince of Egypt*, as the theme song for the production. The producer carefully chose the song because of its message of hope and collective strength for the future, especially in the wake of September 11 and the sufferings and struggles experienced by deaf people worldwide. In this way, the production emphasized the talents and contributions of deaf people everywhere.

More than 7,000 people fill the Washington Convention Center for the event.

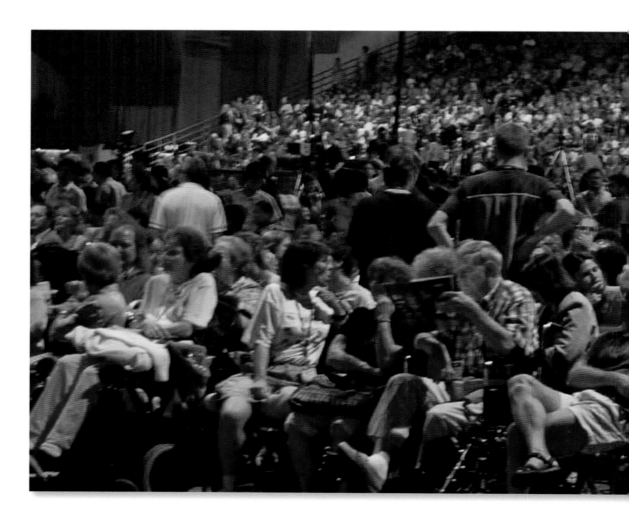

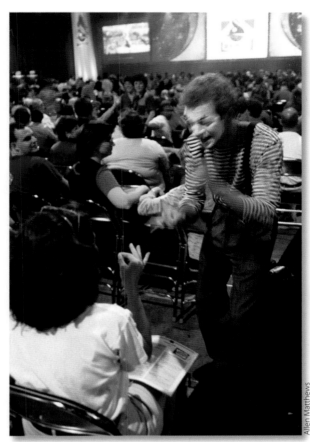

Before the celebration began, performers such as Bill Carwile, far left, a deaf mime, entertain the audience.

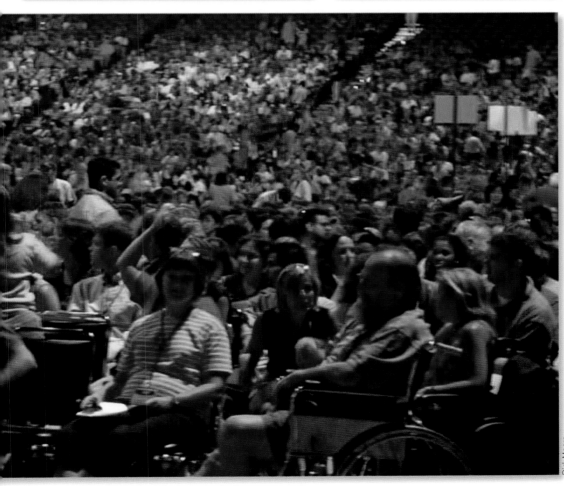

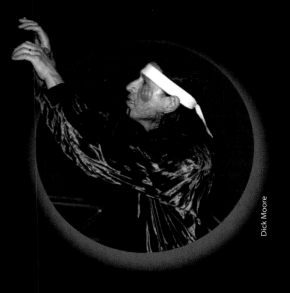

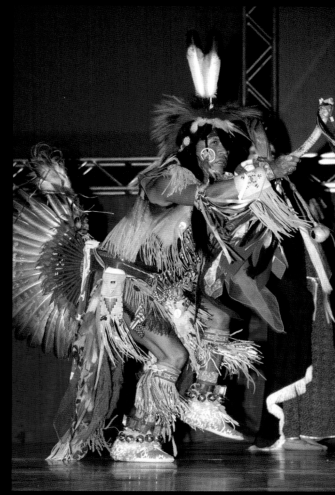

Dick Moore

Deaf Native Americans, including Danny Lucero, above, perform a blessing ritual as the program opened. Afterward, colorful waving banners introduce the celebration, below.

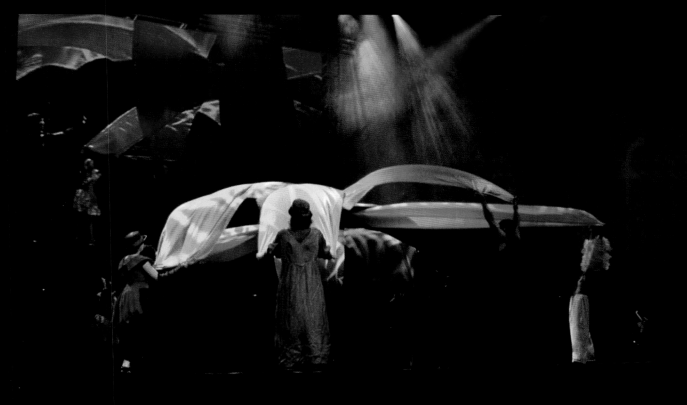

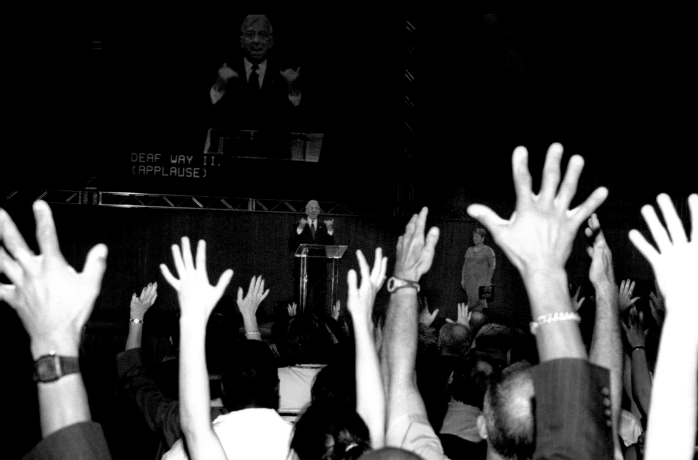

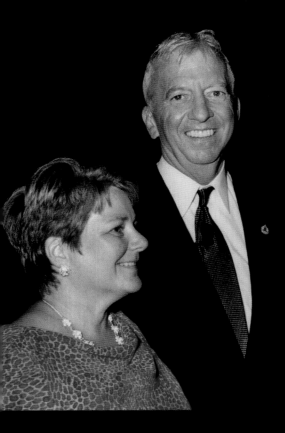

Gallaudet University President I. King Jordan with his wife Linda, left, officially declare the start of Deaf Way II. President Jordan's inspiring speech draws an enthusiastic response from the crowd, below.

Mitko Androv

Deaf Way II Chair
Harvey Goodstein
welcomes the
audience to the
conference and arts
festival, far right.

Speakers Glenn
Anderson, Andrew
Lange, Liisa Kauppin-
en and Nancy Bloch
wait their turn to
welcome the crowd
to Deaf Way II.

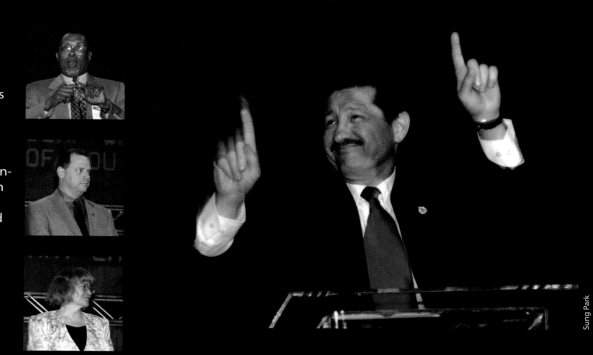

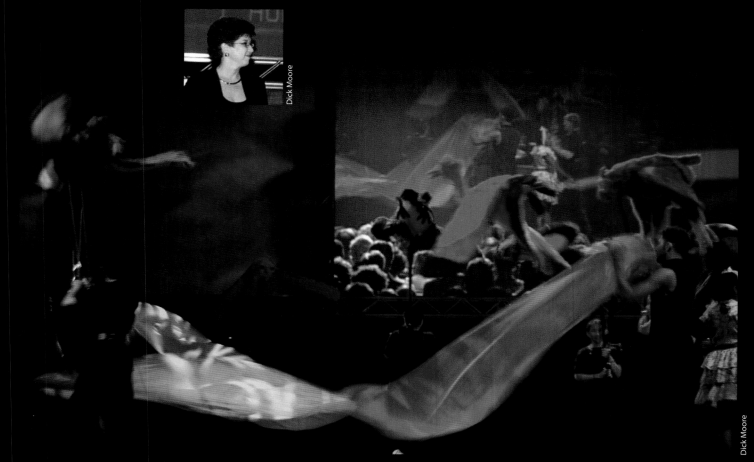

Dick Moore

Sung Park

Dick Moore

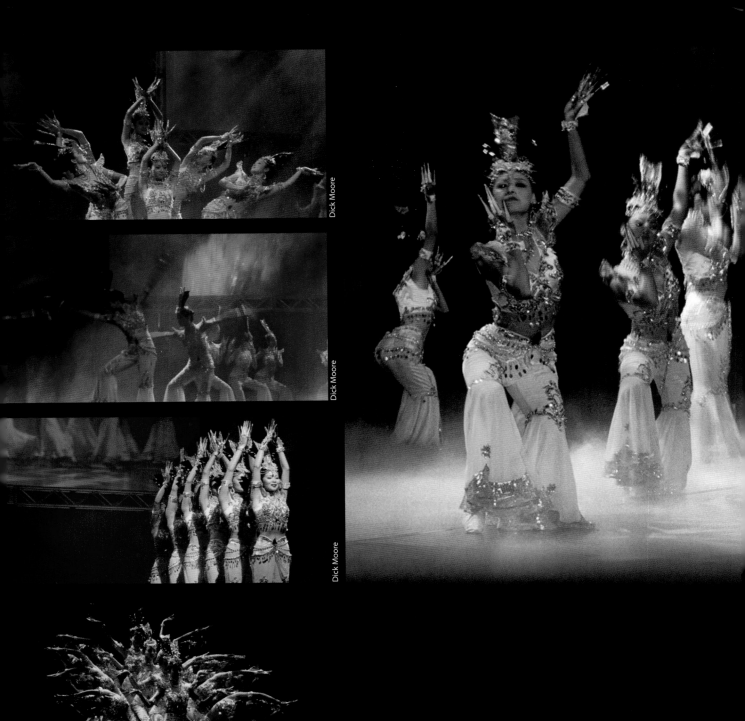

Dick Moore

Dick Moore

Dick Moore

Young Park

The My Dream dancers from the China Disabled People's Performing Arts Troupe mesmerize the audience with their "Thousand-Hand Bodhisattva" dance.

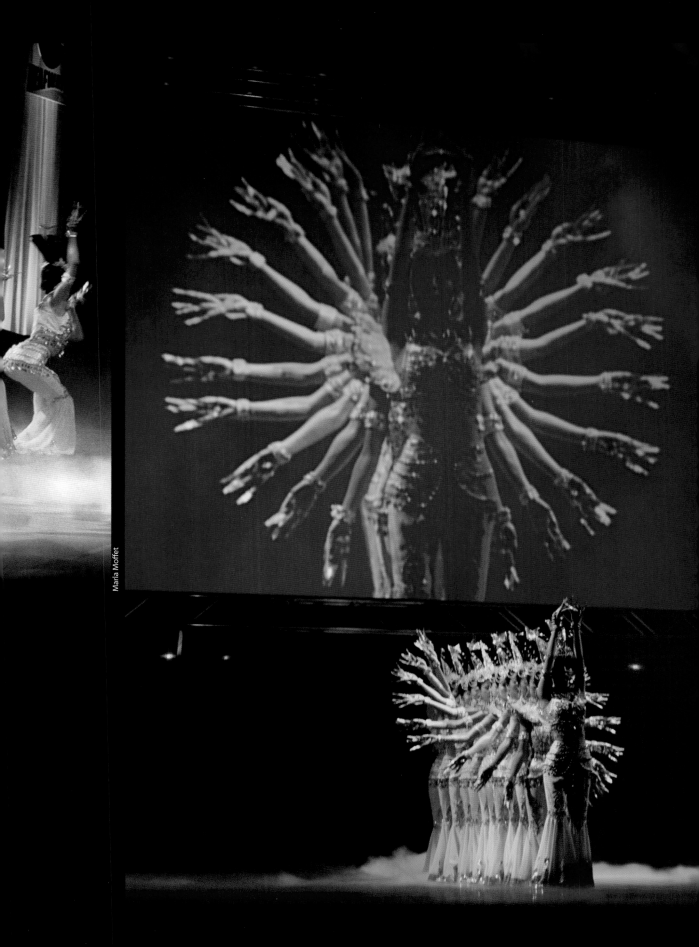

Maria Moffet

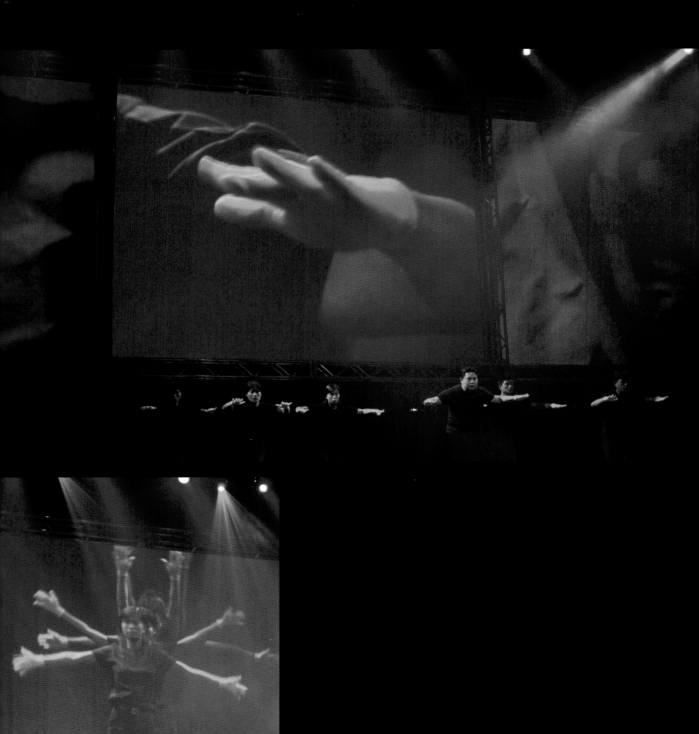

The Hong Kong Theatre of the Deaf, left and above, dazzles the audience with a display of moving hands.

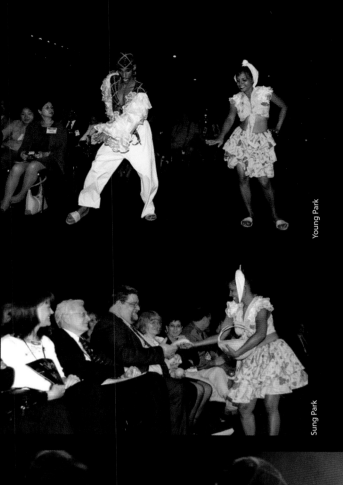

Young Park

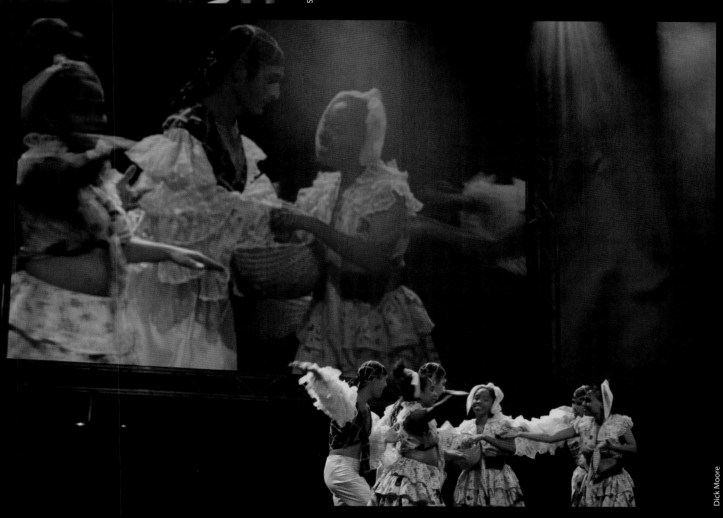

Sung Park

The National Association of Deaf People of Cuba (ANSOC) troupe brings a Caribbean beat to the program.

Dick Moore

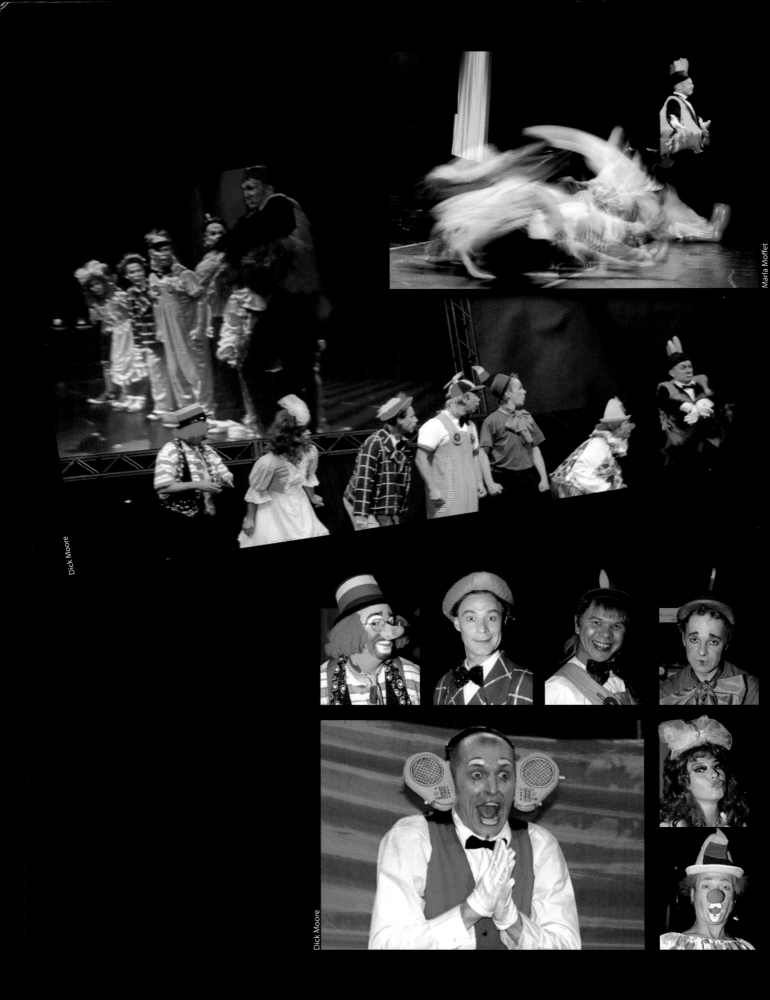

Marla Moffet

Dick Moore

Dick Moore

Clowns from all over the world open the celebration with a comedy of errors.

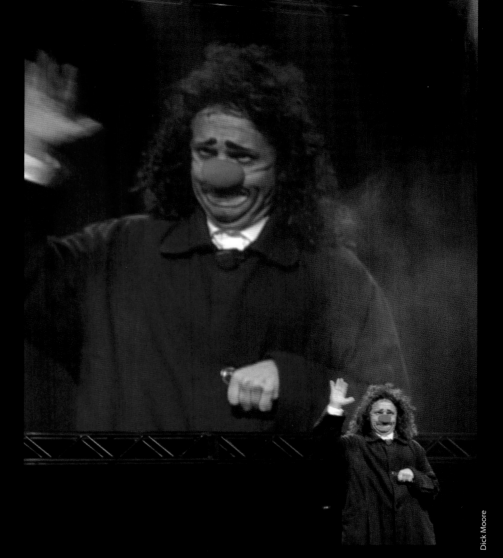

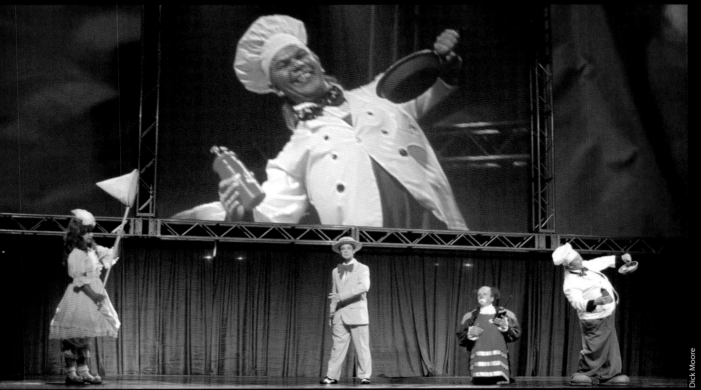

formers such
obert Farmer,
ivate the

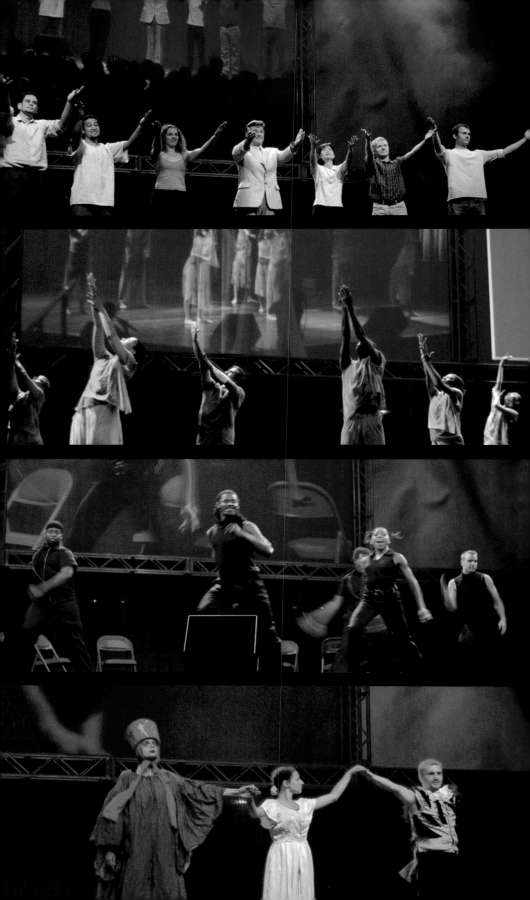

A myriad of children sing and sign the finale's "What You Believe."

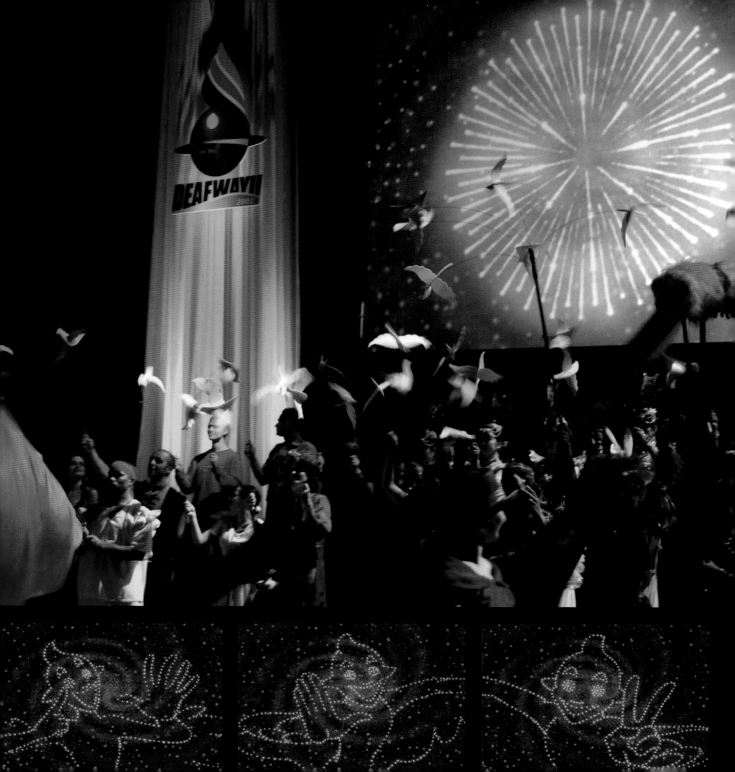

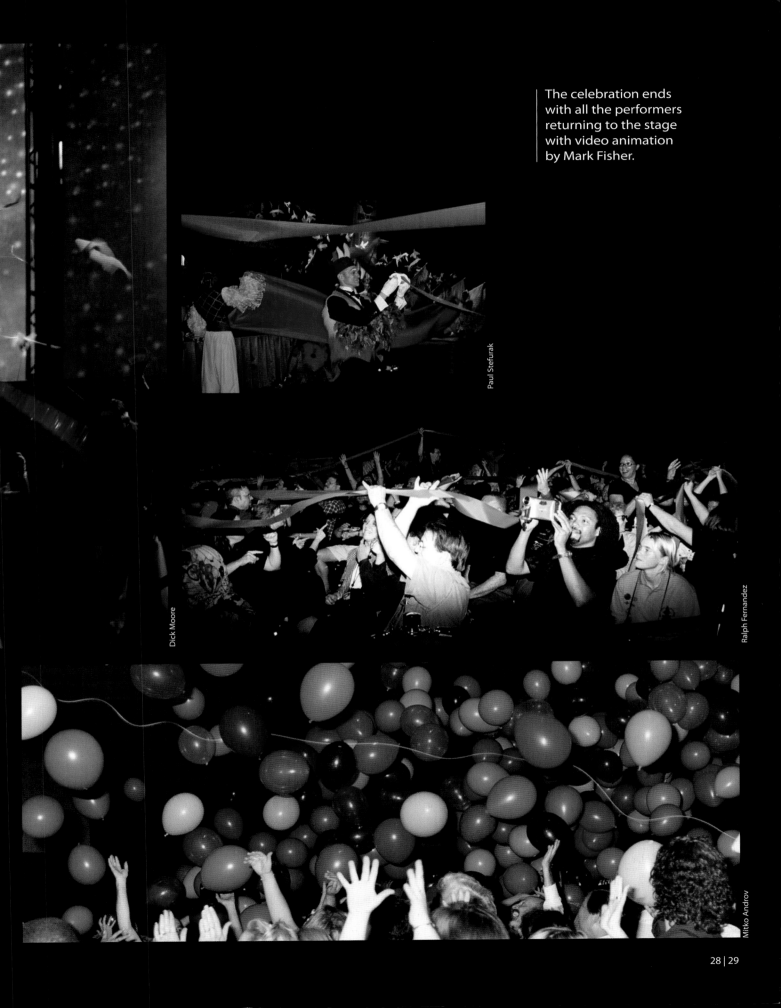

The celebration ends with all the performers returning to the stage with video animation by Mark Fisher.

Paul Stefurak

Dick Moore

Ralph Fernandez

Mitko Androv

Mitko Androv

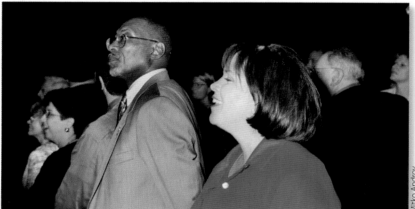

Mitko Androv

Dick Moore

Mitko Androv

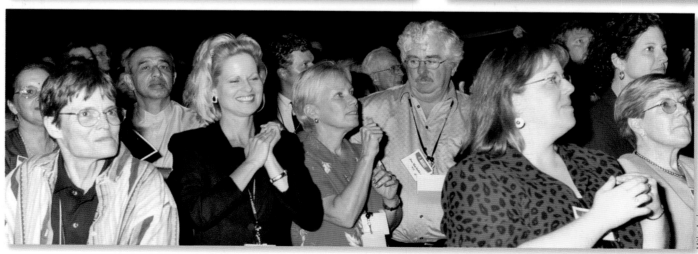

Mitko Androv

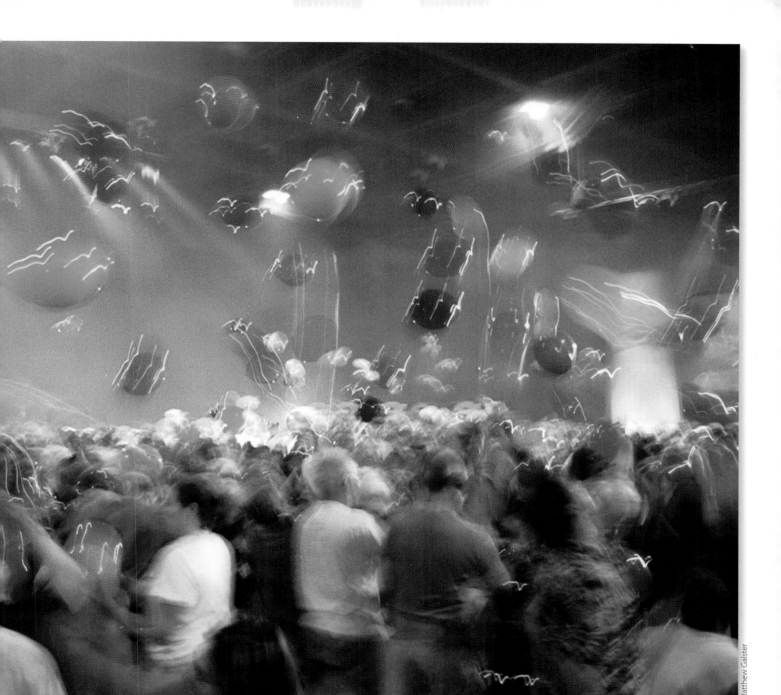

Matthew Galster

Deaf Way II Chair Harvey Goodstein and his wife Astrid, top left, search for their seats; Gallaudet Board of Trustees Chair Glenn Anderson and Gallaudet Provost Jane Fernandes, middle, enjoy the spectacle; and Cultural Arts Producer Tim McCarty and Opening Celebration Director Iosif Schneiderman rejoice at the completion of a wildly successful Opening Celebration.

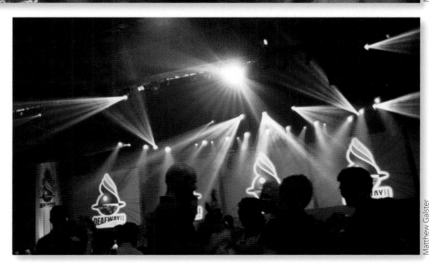

Matthew Galster

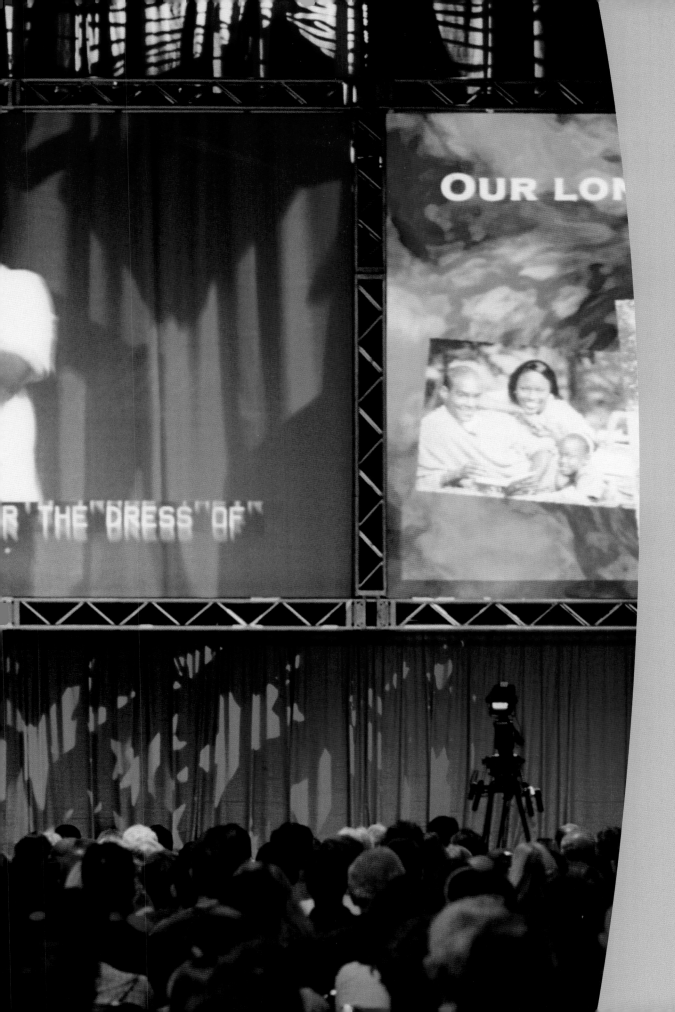

CONFERENCE PROGRAM

Almost 10,000 participants from 121 countries came together for Deaf Way II to share their findings, experiences, and cultures, to learn from one another, and to imagine the future. The Conference Program gave attendees the academic forum to do just that. The program's 15 plenary and 200 breakout sessions were organized into 12 major categories: advocacy and community development; economics; education; family; health—both physical and mental; history; language and culture; literature; recreation, leisure, and sports; sign language and interpretation; technology; and youth.

Raymond Oglethorpe, the president of America Online and the father of a Gallaudet alumna, opened the conference with his keynote address "Making Ourselves Heard: The Promise of No-Barriers Communication." His speech focused on technological changes, such as instant messaging and wireless pagers, that shape the lives of deaf and hard of hearing people worldwide.

Technological issues, however, were only a small part of the Conference Program. Presenters addressed subjects as diverse as implementing strategies to ensure appropriate education for deaf and hard of hearing students; overcoming obstacles in the adoption of deaf and hard of hearing children; accessing health and mental health services; and examining changes in attitudes toward cultural diversity. Other speakers assessed the impact of governmental changes on the Deaf community's lifestyle; shared research on learning native sign languages and models for training interpreters; promoted youth programs and the development of future leaders; and shared success stories of owning a business, managing a service center, or achieving other significant accomplishments.

Between sessions, participants and the public could visit the Exhibition Hall, which featured more than 150 exhibitors and vendors displaying crafts, information on educational programs, books, and more. At the exhibition, many people saw for the first time cutting-edge technology such as two-way text pagers with multiple features, Internet Relay Service, and Video Relay Service. In one of the most unusual exhibits, students in Gallaudet's Young Scholars Programs assembled a replica of a 1965 Shelby 427 Cobra Roadster.

When attendees wanted a change of scenery, they took shuttle buses to the Gallaudet campus. Universally regarded as the flagship institution for promoting the education, training, and empowerment of deaf and hard of hearing students, Gallaudet University hosted Deaf Way II. During the conference, volunteer guides led tours of the campus to help attendees appreciate the university's historical significance and its state-of-the-art facilities. Visitors were able to walk through Gallaudet's new Student Academic Center to look at several prototypical high-tech classrooms and laboratories designed for use by deaf and hard of hearing students.

For many attendees, encountering thousands of successful deaf and hard of hearing people was an eye-opening and overwhelming

Advocacy
Community Development Economics Education Family

Health/Mental Health History Language/Culture Literature

Recreation/Leisure/Sports Sign Language
Interpretation Technology Youth

Allen Matthews

Keynote speaker and AOL President Raymond Oglethorpe poses for pictures with plenary speaker and CSD CEO Benjamin Soukup, far left, after the first day's opening remarks and keynote address.

Benjamin Soukup welcomes attendees to the conference and introduces Raymond Oglethorpe.

DEAFWAYII
2002

RAY IS NOT ONLY PRESIDENT OF
THE WORLD'S BEST

Allen Matthews

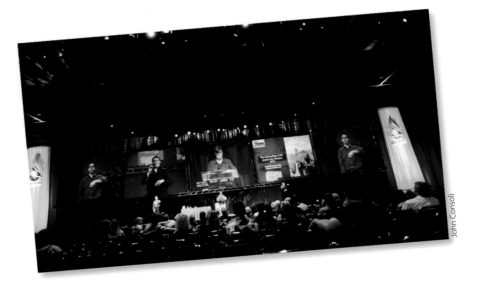
John Consoli

experience. This interaction gave many people the opportunity to network and to learn what was possible for their communities. Empowered and excited, the conference goers returned home changed and ready to improve the quality of education, services, and life for deaf and hard of hearing people worldwide. As Benjamin Soukup, founder and CEO of Communication Service for the Deaf (CSD), a title sponsor of Deaf Way II, summed up in his plenary speech, "We are here to benefit not ourselves but our future."

Keynote and Plenary Speakers

Keynote Speaker

- Raymond Oglethorpe
 president, America Online, Inc., United States

Plenary Speakers

- Thomas Harkin
 senator, United States

- Benjamin Soukup
 chief executive officer, Communication Service for the Deaf (CSD), United States

- Liisa Kauppinen
 president, World Federation of the Deaf, Finland

- Wilma Newhoudt-Druchen
 parliament member, South Africa

- Clark Denmark and Frances Elton
 sign language researchers and authors, England

- Laurene Gallimore
 educator and civil rights advocate, United States

- Yutaka Osugi
 linguist and researcher, Japan

- Rune Anda
 adoption and child advocate, Norway

- Barbara Brauer
 psychologist, United States

- Maria Tanya de Guzman
 mental health counselor, Philippines

- Elena Silianova
 educator and researcher, Russia

- Joseph Murray
 president, World Federation of the Deaf Youth Section, United States

- Heidi Zimmer
 adventurer/motivational speaker, United States

- Peoungpaka Janyawong
 deaf advocate, Thailand

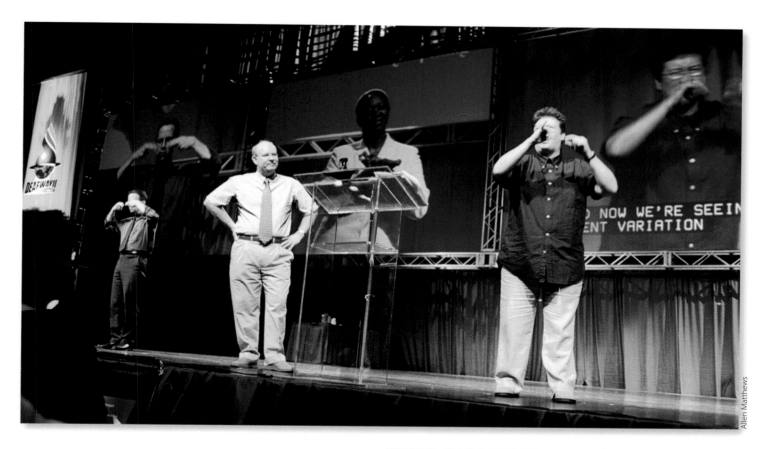

Allen Matthews

Plenary speakers Clark Denmark and Frances Elton discuss how changes in the deaf population, the media, and other factors influence Deaf culture.

Plenary speaker Peoungpaka Jan-yawong shows a television advertisement created and distributed by deaf Thai people in Asia.

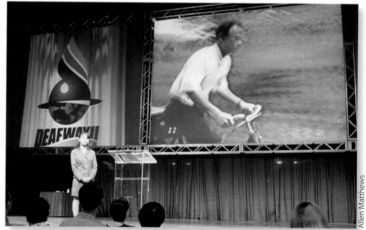

Allen Matthews

John Consoli

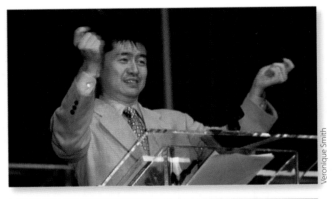

Veronique Smith

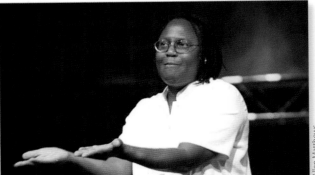

Allen Matthews

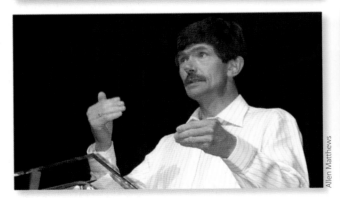

Allen Matthews

Allen Matthews

The conference's fifteen plenary speakers, including, from top left, Yutaka Osugi, Laurene Gallimore, Rune Anda, Heidi Zimmer, Wilma Newhoudt-Druchen, and, opposite page, Barbara Brauer, top right, Liisa Kauppinen, middle, Joseph Murray, bottom, and Maria Tanya de Guzman, far right, explore a variety of issues relevant to the Deaf community, from the development of sign language on an isolated island off of Japan to deaf adoptions.

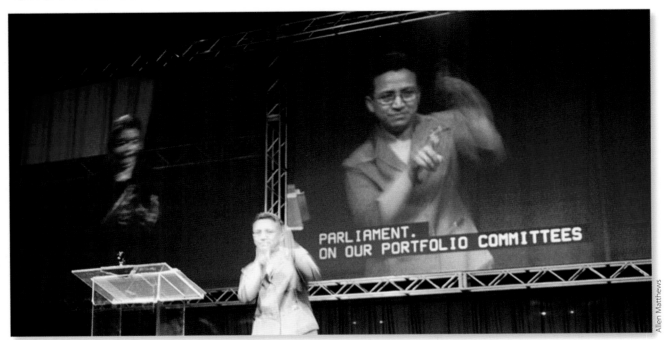

PARLIAMENT.
ON OUR PORTFOLIO COMMITTEES

Allen Matthews

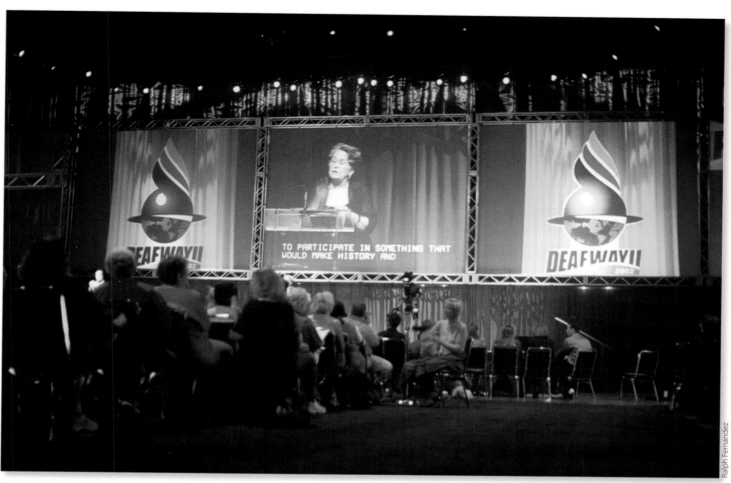

TO PARTICIPATE IN SOMETHING THAT
WOULD MAKE HISTORY AND

Ralph Fernandez

Allen Matthews

Allen Matthews

Allen Matthews

Veronique Smith

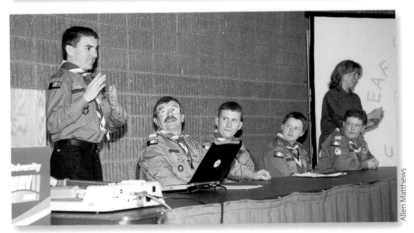

Veronique Smith

Allen Matthews

Allen Matthews

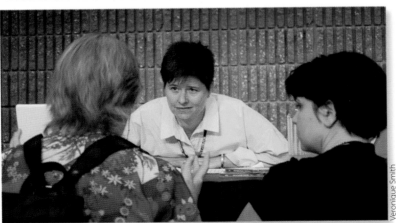

Veronique Smith

In her presentation, Johanna Mesch discusses the importance of tactile interpreters using clear references, especially with complex stories.

Madan Vasishta discusses how deaf people live and associate in India with its huge population, economic diversity, and caste system.

Vlad Grigoriev directs an audience member to act like a moose to show sign language instructors how to help their students become comfortable using facial expressions and body language when signing.

Presenters from the Ireland Deaf Scout Unit seek to encourage the World Deaf Scout Movement through their panel.

After the conclusion of a panel on translating Shakespeare's *Twelfth Night* into ASL, attendees rush forward to ask the presenters about the process.

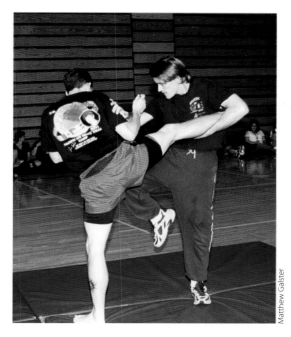

Matthew Galster

Floyd Jackson, left, and his assistant Delbert Bunn demonstrate martial art moves at Gallaudet's Field House.

Junhun Yang and Jianghong Zhao present Experiences of Chinese Families with Successful Deaf people, below.

Veronique Smith

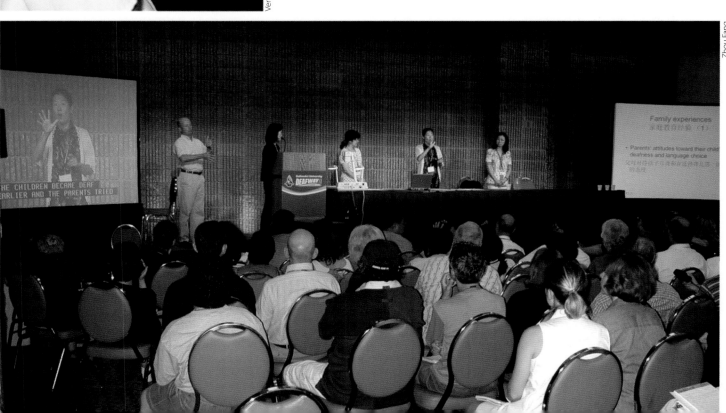

Zhou Fang

Veronique Smith

Veronique Smith

Veronique Smith

Veronique Smith

Veronique Smith

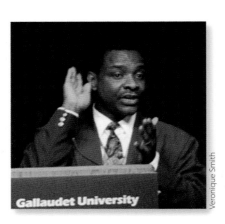

Gallaudet University

Veronique Smith

Allen Matthews

The conference's week of presentations fully represented the depth and breadth of issues relevant to the international Deaf community.

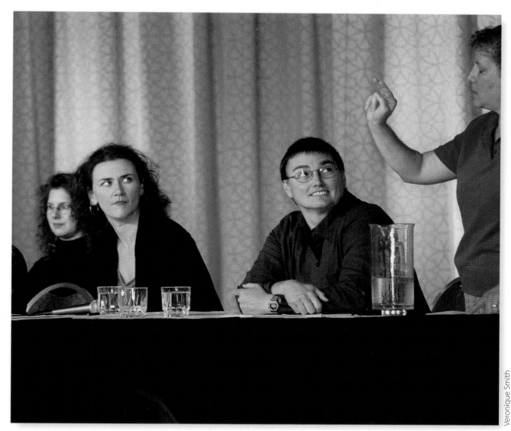

Panelists of the tactile sign language group session, right above, discuss on-going research studying the linguistic properties of tactile ASL. Paul Ogden, right, autographs his book *The Silent Garden: Raising Your Deaf Child*.

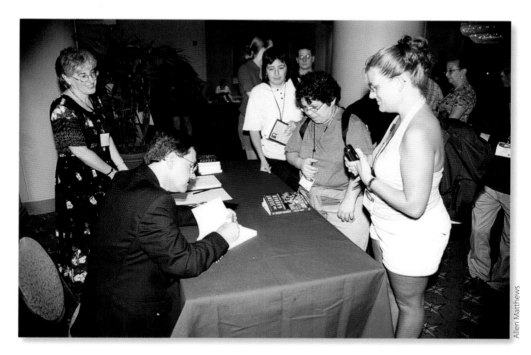

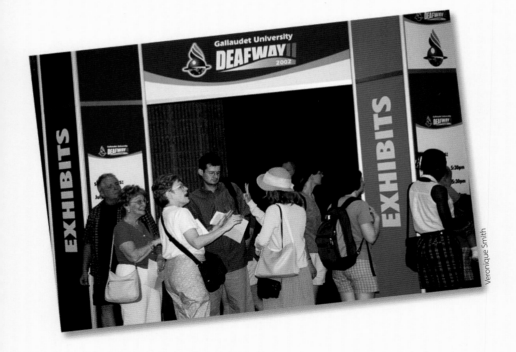

Veronique Smith

The Deaf Way II Exhibition Hall featured more than 150 displays of the latest technology, books, art, and educational material of interest to deaf people.

Marla Moffet

Allen Matthews

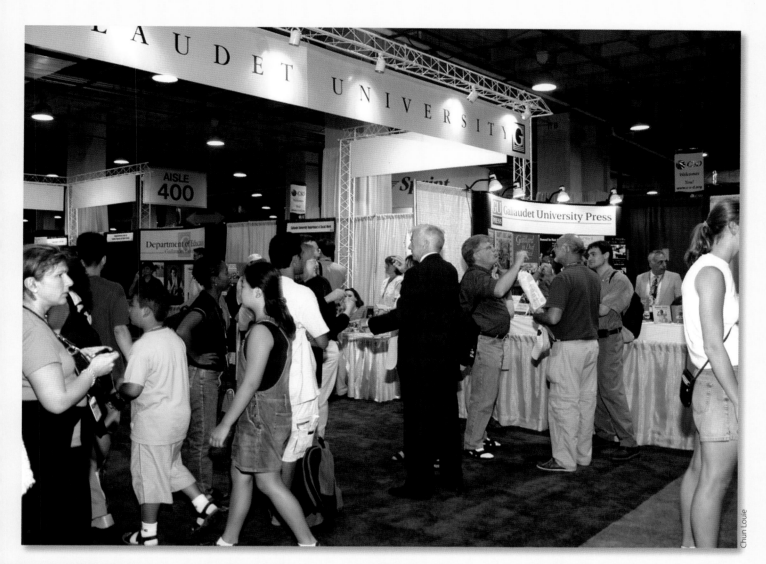

Chun Louie

Jennifer Hinger

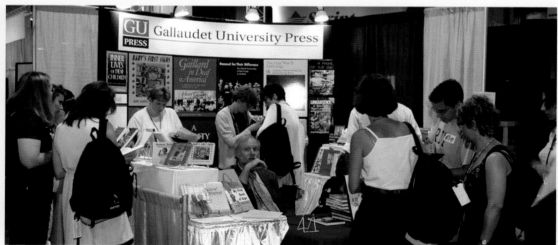

Chun Louie

Veronique Smith

A representative from Communication Services for the Deaf (CSD), Deaf Way II's title sponsor, explains the organization's services to a large crowd, below.

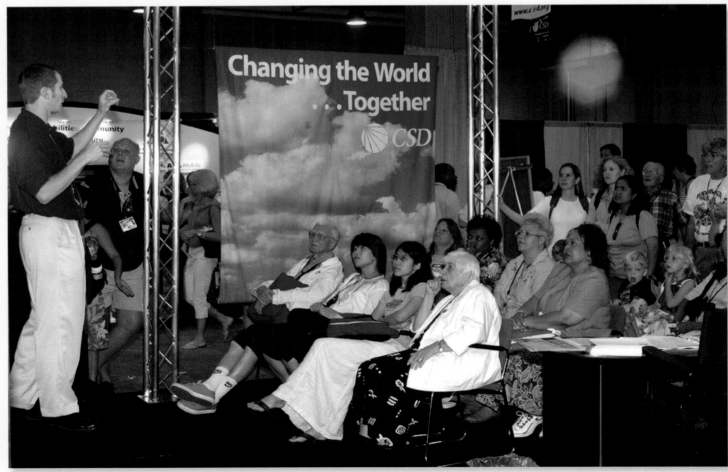

Dick Moore

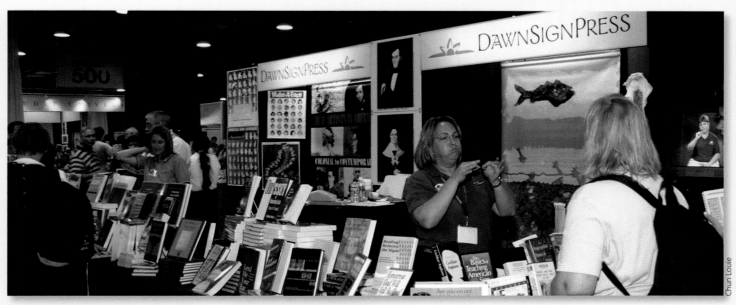

Chun Louie

Dick Moore

Chun Louie

Chun Louie

Chun Louie

All the exhibitors were busy in their booths, answering questions and discussing their products with attendees.

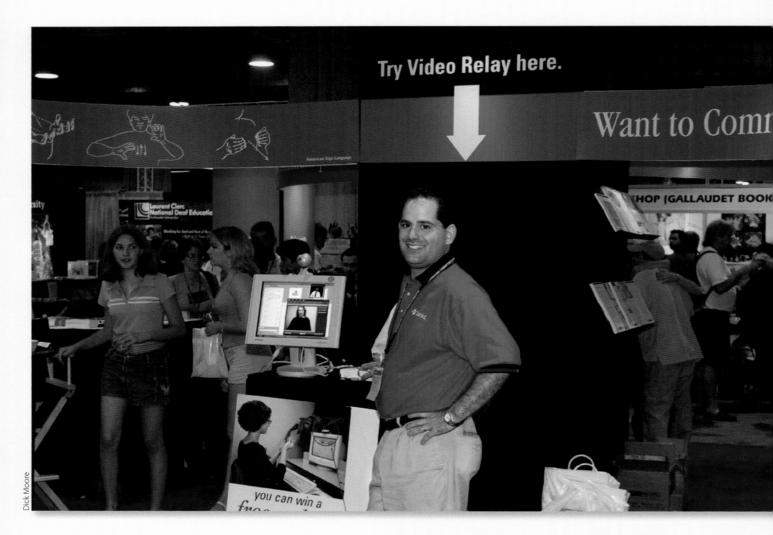

Try Video Relay here.

Want to Comm

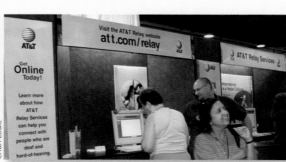

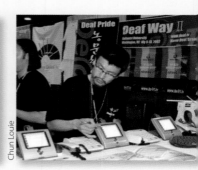

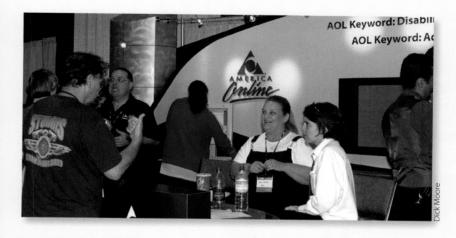

America Online

AOL Keyword: Disabili
AOL Keyword: Ad

Dick Moore

Attendees could try out new technologies like video relay, text messaging, and more from companies like America Online, Verizon, AT&T, and Ultratec in the Exhibit Hall.

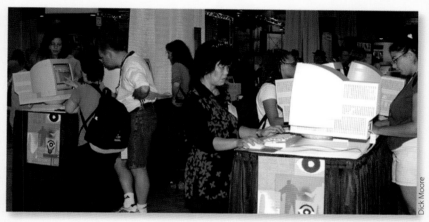

Dick Moore

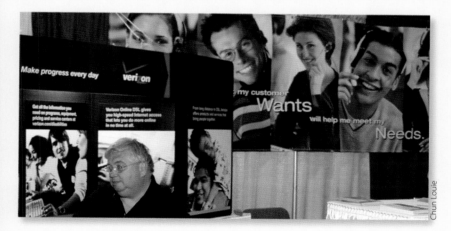

Make progress every day verizon

my customer

Wants

will help me meet my

Needs.

Chun Louie

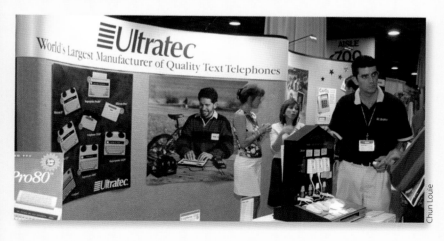

Ultratec
World's Largest Manufacturer of Quality Text Telephones

Pro80

Ultratec

Chun Louie

Visitors shop for arts and crafts at various booths in the Exhibition Hall, including animal portraits by Louis Frisino, above, stained glass by Carlos Hernandez, glass sculpture by Hong Ze, and various drawings and paintings by Iris Aranda, right.

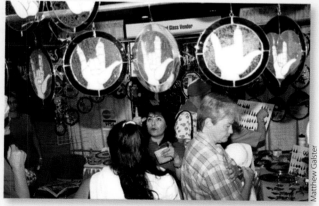

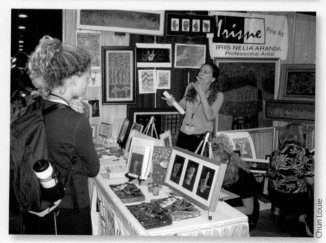

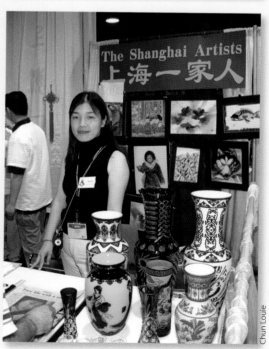

The Shanghai Artists
上海一家人

ARTS FESTIVAL

eightening public awareness and appreciation of deaf and hard of hearing people's talents and abilities was one of the main objectives of Deaf Way II. The International Arts Festival, featuring artists and performers in venues all over Washington, D.C., provided an excellent means of accomplishing that goal. Many festival events were open to the public and introduced the art and culture of deaf people to large audiences. More people, approximately 400,000, were exposed to deaf culture and issues through the arts festival, the Deaf Way II web site, National Public Radio, newspapers, and other media outlets.

Though the conference only lasted one week, the arts festival began in May 2002 and ran through September of that year. History Through Deaf Eyes, a traveling social history exhibition about deaf and hard of hearing people, opened at the Smithsonian's Arts and Industries Building on May 9 and closed September 10. More than 260,000 visitors flocked to that exhibit within two months of its opening. Other Deaf Way II exhibits at local galleries and museums lasted more than a month, usually stretching from June to August. The Smithsonian's 2002 Folklife Festival, titled The Silk Road: Connecting Cultures, Creating Trust, featured performances by many Deaf Way II artists, such as the Hong Kong Theatre of the Deaf, the My Dream classical dancers from China, the contemporary Indian dancers Astad Deboo and Karthika, and the Japanese Theatre of the Deaf. As one observer noted, it was exhilarating to see thousands of Folklife Festival spectators on the National Mall carrying the orange booklet *Deaf Way II: An International Arts Festival*. The booklet was widely distributed at the various Deaf Way II venues around the Washington metropolitan area.

The History Through Deaf Eyes exhibit at the Smithsonian's Arts and Sciences Building drew more than 260,000 visitors within two months of its opening. Many thousands were at the Smithsonian's Folk Festival, which included performances by Deaf Way II artists from Japan, Hong Kong, China, and India. At the Kennedy Center, the Russian artists' exhibition received more than 1,000 visitors, and the five-day performances at the Millennium Stage drew more than 3,000 visitors. The Deaf Way II program partners responded favorably to the partnership experience, due to large crowd turnouts described above, and are eager for additional collaborative efforts in the future.

Literary Arts

Performing Arts

Visual Arts

Literary Arts

All conference attendees received *The Deaf Way II Anthology: A Literary Collection by Deaf and Hard of Hearing Writers*, edited by Tonya M. Stremlau, as part of their registration packet. The book contains poetry, essays, short stories, and one play written by sixteen international writers who share their experiences and personal universes as deaf people and offer insights on the complete human experience. Authors featured in the anthology presented daily readings and discussions of their works throughout the conference. They also discussed the challenges of being deaf writers and of promoting and encouraging other deaf writers.

Matthew Galster

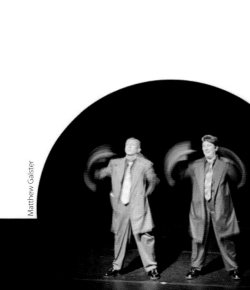

Marla Moffet

Michael Velez and Sherry Hicks of Half-n-Half, above, combine ASL, music, and storytelling in a CODA-centric performance that delights the audience.

Julia Brendle, Angelika Eisele, and Thomas Goepfert of Germany's Telos modern dance troupe, left, perform in the *Global Movement: The World of Deaf Dance* program.

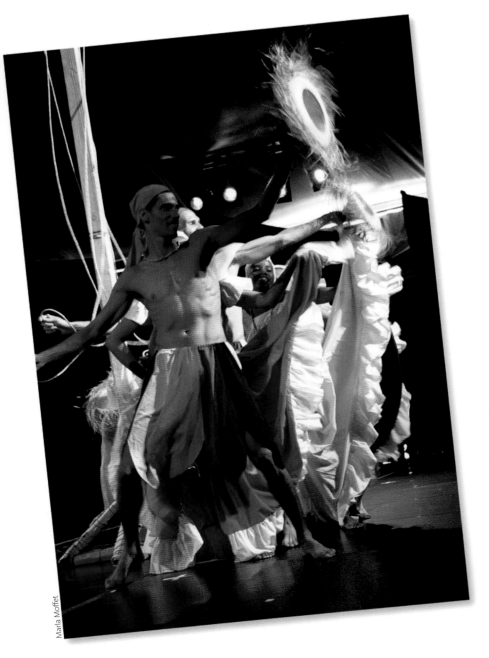

Marla Moffet

The National Association of Deaf People of Cuba (ANSOC) dancers perform *A Celebration of Cuban Folk Dance*.

Dancers from the Hong Kong Theatre of the Deaf, opposite page, paint a "moving" moment in *Creation*, an epic story from the beginning of time to the present day.

Performing Arts

Performances by international theatre troupes and individual artists were hosted by Gallaudet and other venues around the city, including the Clarice Smith Performing Arts Center at the University of Maryland, the John F. Kennedy Center for the Performing Arts, the Smithsonian Discovery Theater, and the Publick Playhouse. In addition, two 300-seat theaters in one large tent were set up on the Gallaudet campus during the conference and named "Bernard Bragg Theatre on the Green" and "Phyllis Frelich Theatre on the Green" in honor of two internationally known deaf stage actors.

Several international deaf theatre groups gave performances with strong national, cultural, or sociopolitical themes. Others emphasized visual movements with or without music. Some incorporated deaf cultural traits, twists, and humor. Two performances were commissioned especially for Deaf Way II—*Black and Deaf in America: A Glimpse toward Home*, a collection of humorous and moving vignettes, and Pentimento, a dance troupe made up of some of the most talented deaf dancers and choreographers from all over the world. They came together for the first time only four weeks prior to Deaf Way II. Other types of performing arts in the festival included mime, storytelling, and magic shows.

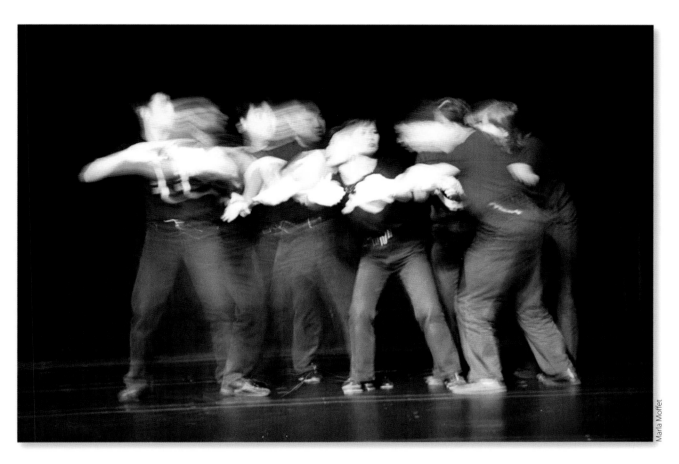
Marla Moffet

The Norwegian Sign Language Theater's *Little Red Riding Hood* tells her story while the Big Bad Wolf hides behind a drape.

A performance by Pentimento, below, which was commissioned for Deaf Way II and features acclaimed dancers and choreographers from all over the world.

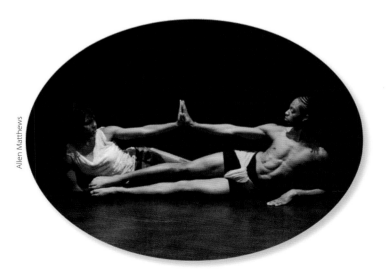
Allen Matthews

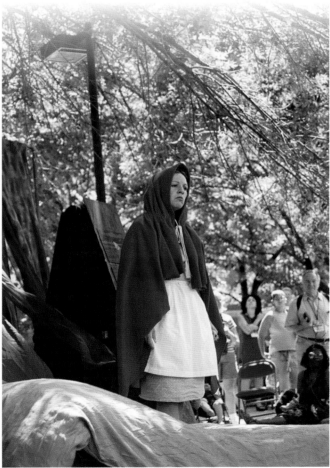
Veronique Smith

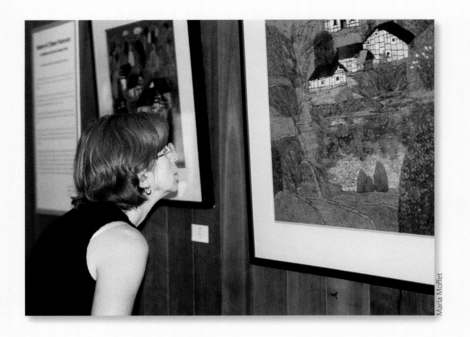
Marla Moffet

Mary Silvestri admires the tremendous detail of a painting in the Masters of Chinese Watercolor exhibit at the National Arboretum.

Colombian sculptor Abelardo Parra Jimenez created the sculpture *Universal Knowledge*, below, especially for Deaf Way II.

Visual Arts

The Main Course exhibit at Gallaudet's Washburn Arts Building provided a sampling of artworks from most of the festival's sixty-nine visual artists. Each piece was accompanied by a sign that listed the work's title, its description, and the other exhibits that were showing more works by that artist. It was a good place to start before boarding the "Great City/Great Art" tour buses, which took participants to art galleries in the Arts and Industries Building, the National Arboretum, the National Zoological Park, the Arthur M. Sackler Gallery, the Kennedy Center, the Millennium Arts Center, and others. Visitors saw works such as *Hearing Aids Are Not Like Glasses, Vibrant Vibes, The Deaf View, African Connection*, and *Relationship in Science*.

Gallaudet University hosted four exceptionally talented artists in residence, three of whom were commissioned to create artwork for Deaf Way II and Gallaudet University. Chuck Baird created a series of flower and handshape paintings titled *Efflorescing*. He also provided numerous internships to undergraduate and pre-col-

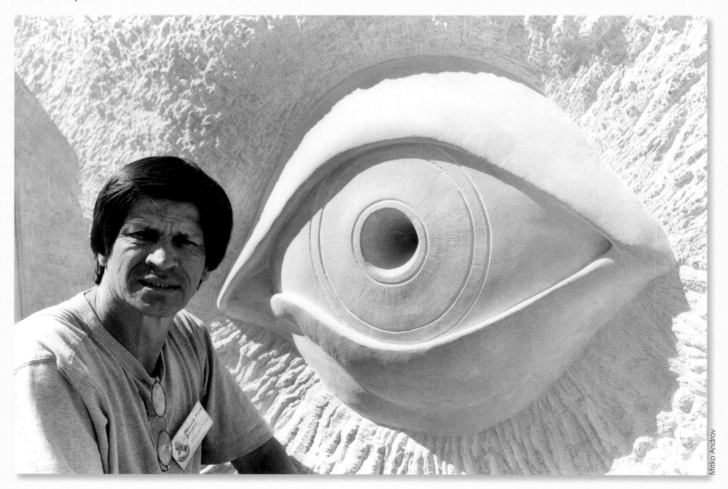
Mitko Androv

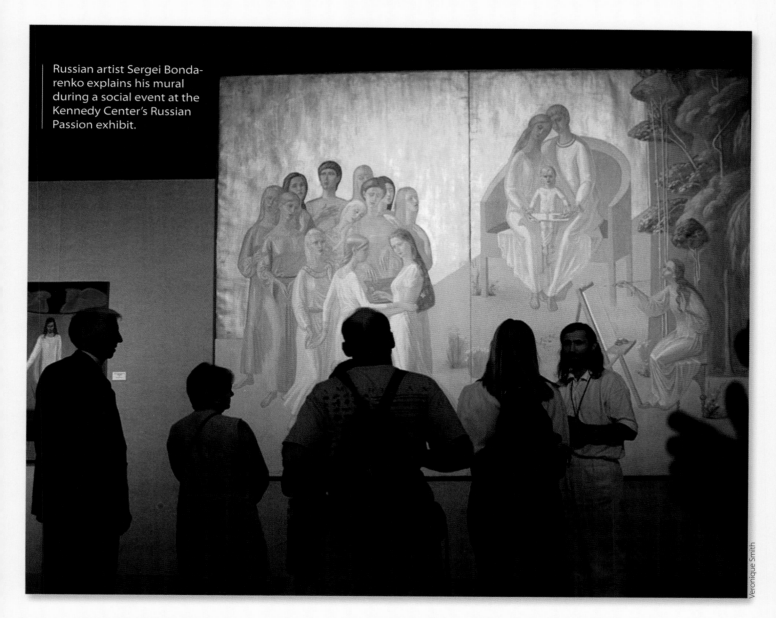

Russian artist Sergei Bonda-
renko explains his mural
during a social event at the
Kennedy Center's Russian
Passion exhibit.

Veronique Smith

lege students. Ingrid Crepeau was invited to teach a spring semester class on puppet-making to Gallaudet undergraduates. Her students created the colorful giant birds with flapping wings, swiveling necks, and chattering beaks used in the Opening Celebration. Abelardo Parra Jimenez carved a large three-dimensional limestone piece, titled Universal Knowledge, which depicted an eye on one side and the universe on the other. Sander Blondeel created a huge oval stained-glass piece, featuring colorful rays shooting upward.

Film and Video Festival

The Film and Video Festival featured more than fifty-five films and videos about, or produced by, deaf and hard of hearing individuals from all over the world. The beauty and originality of sign language, in particular, cannot be pre-

served or portrayed as well in any medium other than video.

The artists and performers networked with one another during the week in order to help create opportunities beyond Deaf Way II. The artists also generously gave a number of hands-on workshops to the conference attendees and campers to enhance their greater appreciation for art. That interaction along with the recent publication of the *Anthology*, the *Deaf Way II Featured Visual Artists* booklet, and the *Film and Video Festival* booklet will go a long way toward helping to document deaf art for mainstream academia, journalism, and museums.

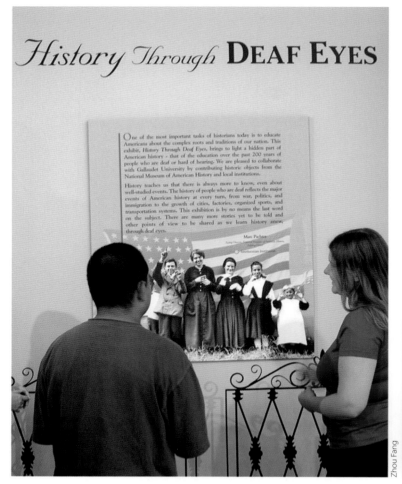

History Through DEAF EYES

Volunteer Trix Bruce, bottom left, explains part of the History Through Deaf Eyes exhibit to Susan Popovich at the Smithsonian's Arts and Industries Building.

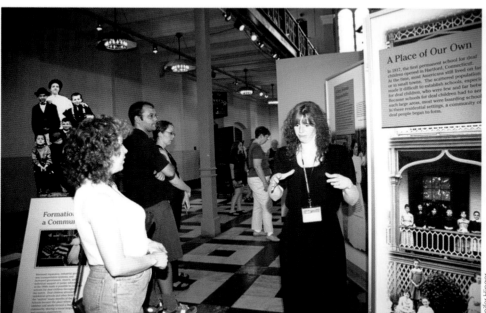

Using objects and images, such as the wooden fingerspelling figures, top left, collected by individuals, organizations, and schools for deaf children, the History Through Deaf Eyes exhibit illustrates the shared experiences of family life, education, and work as well as the divergent ways deaf people see themselves, communicate, and determine their own futures.

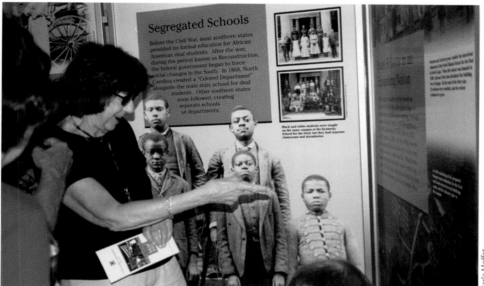

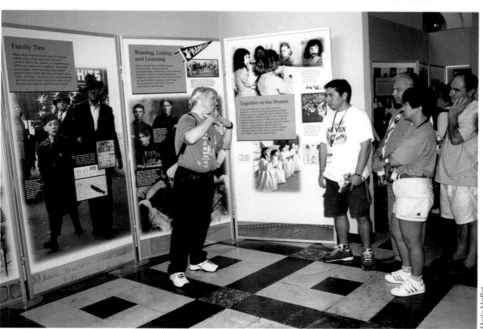

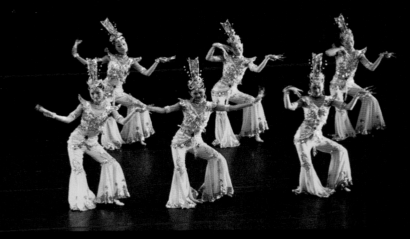

China's internationally acclaimed My Dream dance company performed a variety of traditional Chinese folk dances, including "Spring Outing," which demonstrates a style of dance from the Han Dynasty.

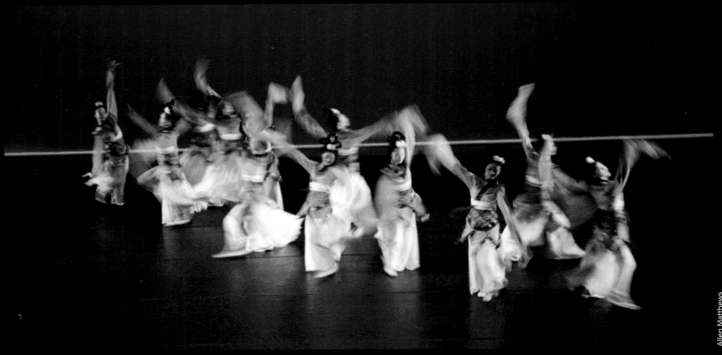

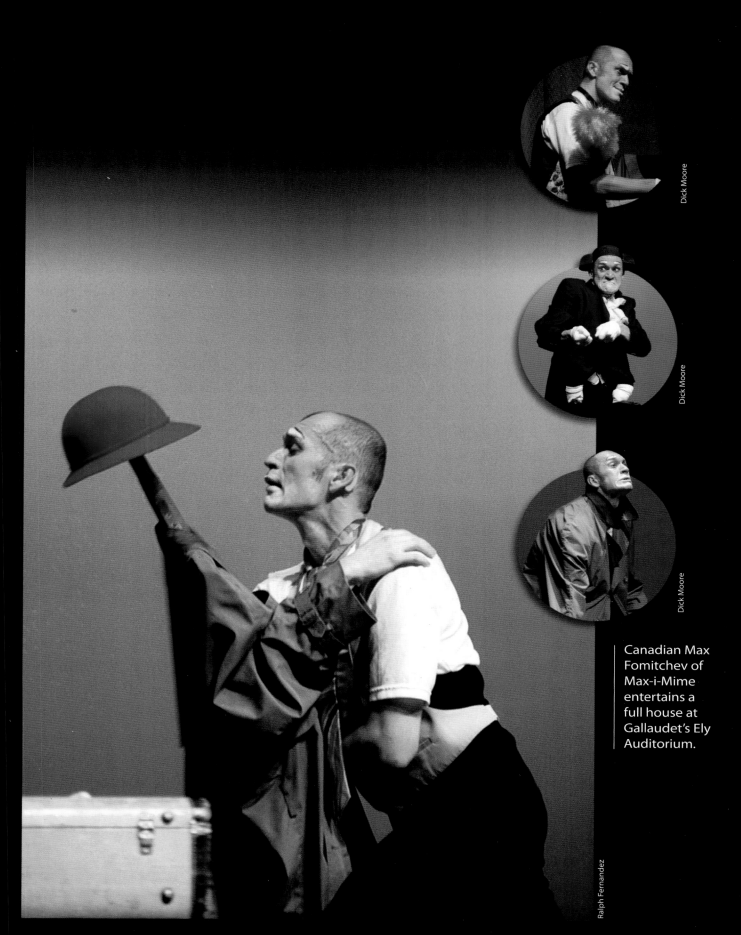

Canadian Max
Fomitchev of
Max-i-Mime
entertains a
full house at
Gallaudet's Ely
Auditorium.

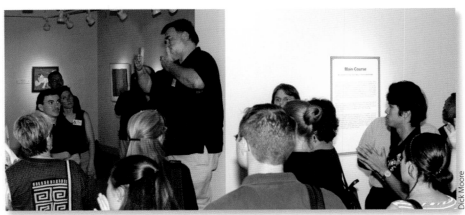

Paintings, sculpture, ceramics, glass art, and other artworks from more than sixty-five Deaf Way II visual artists adorn the Gallaudet campus and eight galleries and museums throughout Washington, D.C.

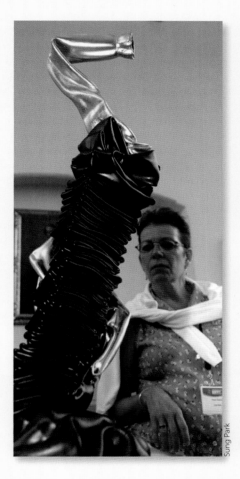

Sung Park

Marla Moffet

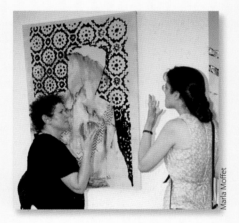

Marla Moffet

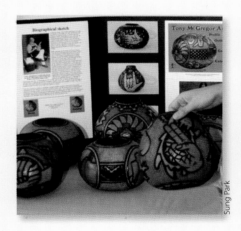

Sung Park

Sung Park

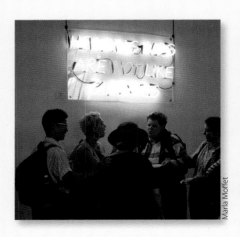

Marla Moffet

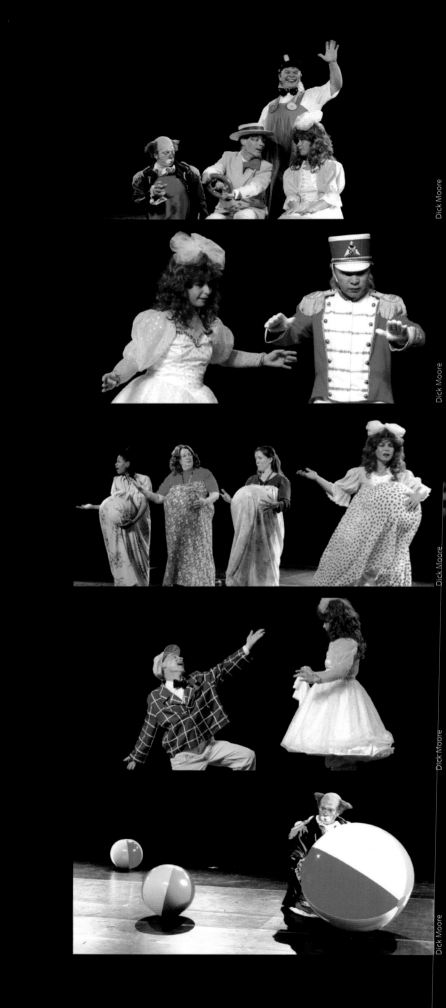

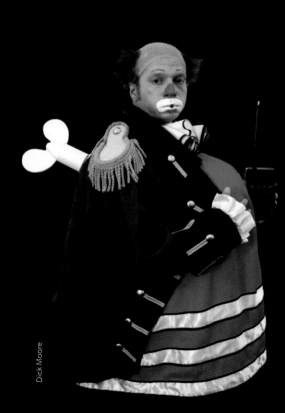

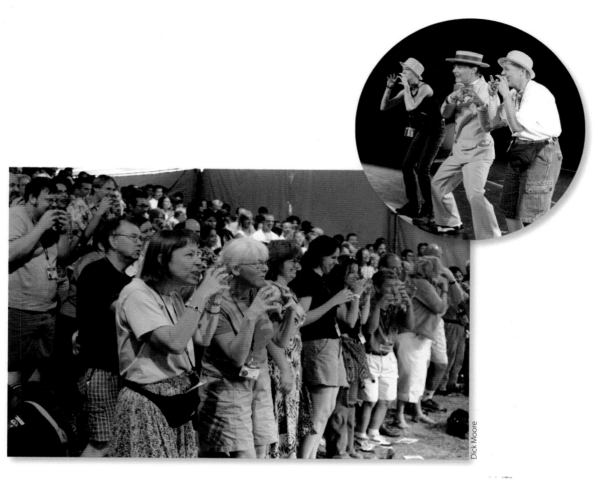

It was well worth the wait in line, right bottom, to see the Russian Theatre's *Toys*, above and opposite page. As one critic commented, "They are four deaf Russian comedians far better than a three-ring circus. You will laugh until you cry."

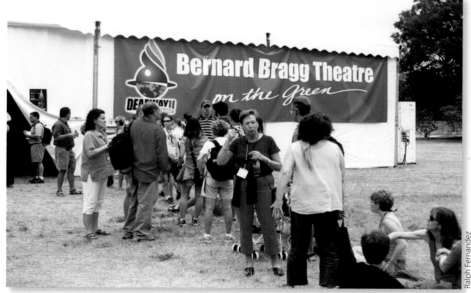

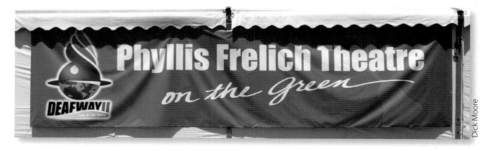

Deaf Way II artist-in-residence Chuck Baird, right, signs his commemorative posters. Russian artist Yuri Chernuha, below, poses in front of his paintings during the Russian Passion exhibit's social event at the Kennedy Center. Another attendee, below left, excitedly holds up her exhibit program book with Chernuha's autograph.

Ralph Fernandez

Ralph Fernandez

Veronique Smith

Dick Moore

Nabil Attia

Visual artists came from all over the world, including Egypt, Russia, Italy, and Mexico, to exhibit their works.

Jennifer Hinger

Marla Moffet

Dick Moore

Zhou Fang

"Delicate Sounds of Silence"

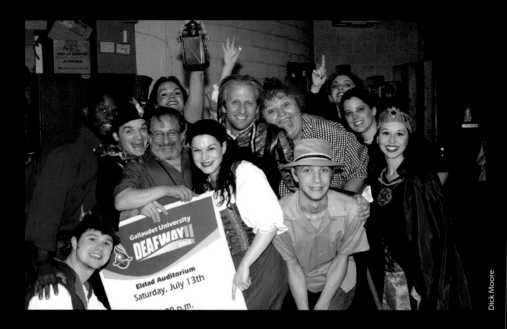

Dick Moore

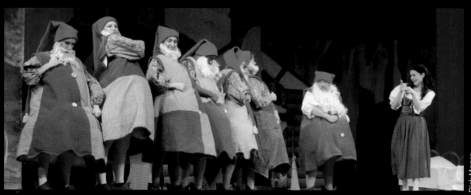

Dick Moore

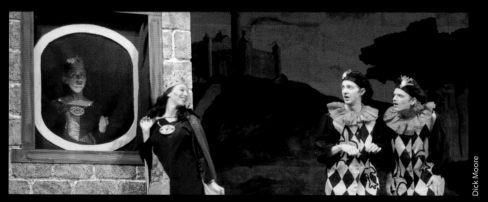

Dick Moore

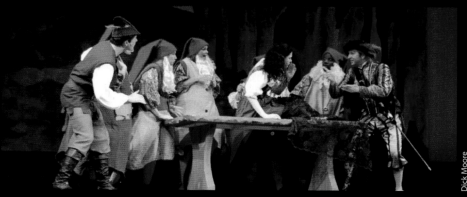

Dick Moore

The Cleveland Signstage Theatre uses both visual and oral forms, including spoken English, sign language, mime, gesture, movement, dance, and other visual arts, in its performance of *Snow White and the Seven Dwarves*.

Dick Moore

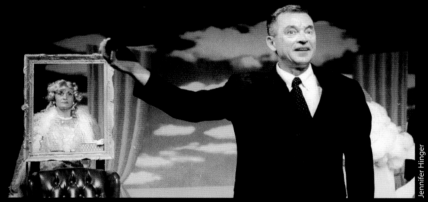

Jennifer Hinger

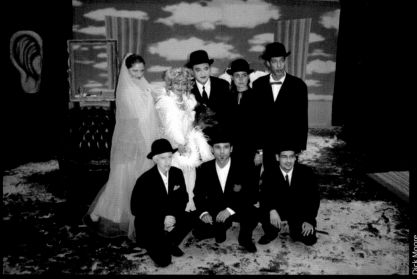

Dick Moore

Dick Moore

Veronique Smith

Marla Moffet

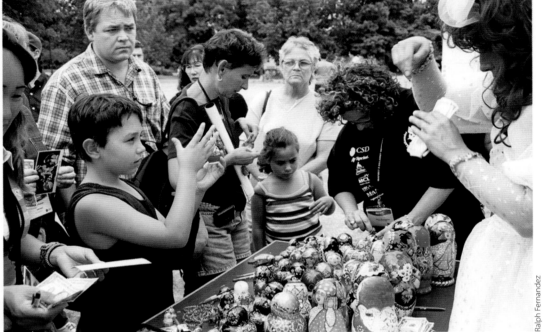

Ralph Fernandez

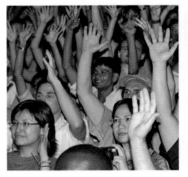

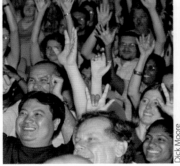

Dick Moore

Ralph Fernandez

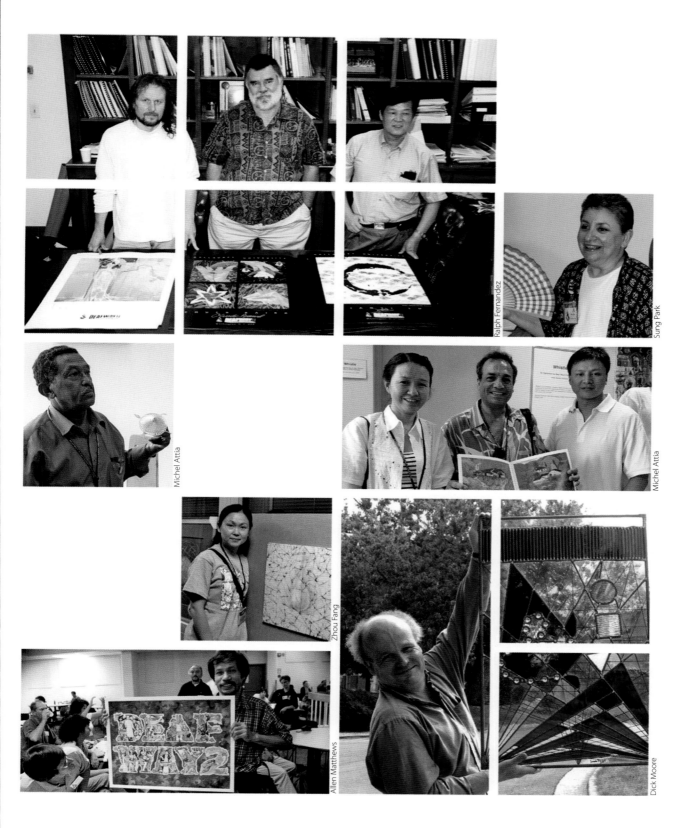

Ralph Fernandez

Sung Park

Michel Attia

Michel Attia

Zhou Fang

Allen Matthews

Dick Moore

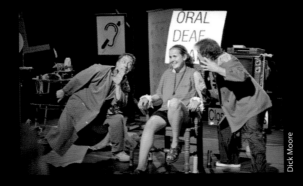
Dick Moore

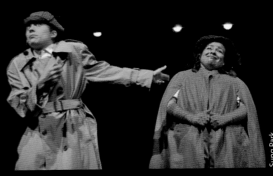
Sung Park

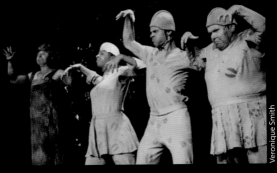
Veronique Smith

Sung Park

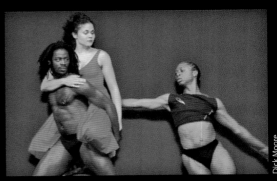
Dick Moore

Marla Moffet

Plays, dances, stand-up comedy routines, and other performances by deaf and hard of hearing entertainers from around the world lit up stages every day and night throughout Deaf Way II week.

Sung Park

Cultural Arts Coordinator Jay Innes, far right, helps to organize and coordinate all of the logistics and planning for the performers, plays, and exhibits.

Dick Moore

Dick Moore

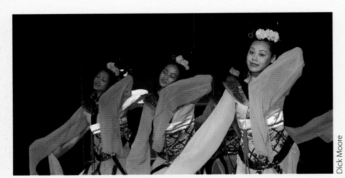

Dick Moore

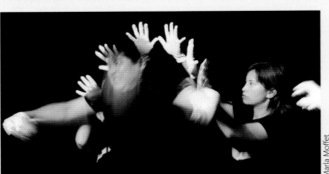

Marla Moffet

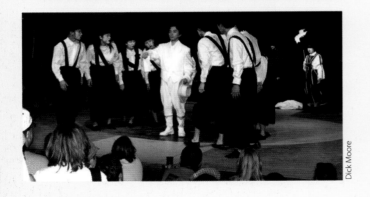

Dick Moore

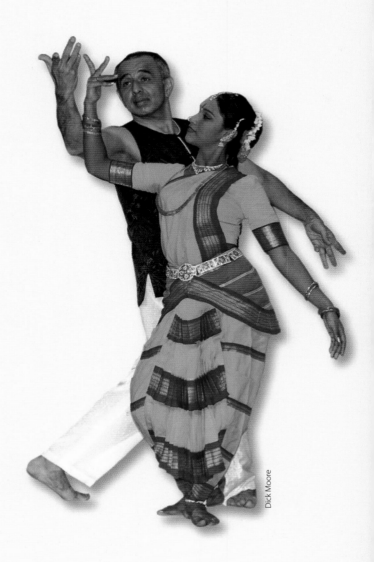

Dick Moore

The Film and Video Festival, right, brought together deaf and hearing filmmakers to present films and videos that feature deaf people from all over the world. Deaf actress Deanne Bray, below, explains her role in the television series *Sue Thomas: F. B. Eye.*

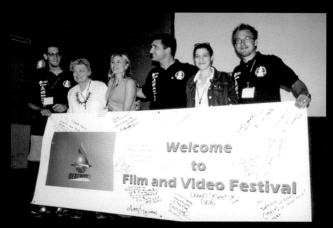

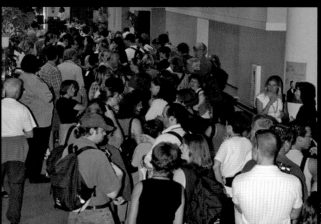

Dick Moore

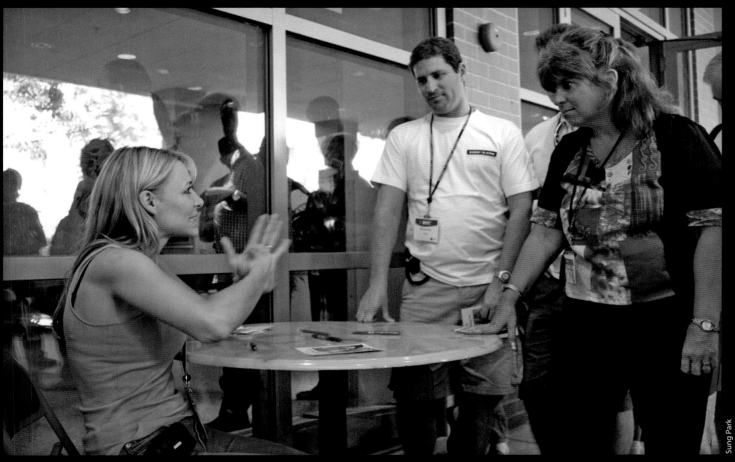

Sung Park

YOUTH PROGRAM

While their parents attended the conference and arts festival, participants in the Youth Program played games, went swimming, learned about Deaf culture, and made new friends during the four-day program. The more than 200 children who participated were split into four age groups: the Young Children's World (ages two to five), the Child Educational Program (ages six to eight), the Pre-Teen Educational Program (ages nine to twelve), and the Teen Camp (ages thirteen to seventeen).

The Young Children's World featured playtime, arts and crafts, naps, cooking lessons, drama lessons, and ASL stories. Older children and preteens learned about sculpture, cardweaving, and painting. They also attended performing arts workshops in dance, visual gestures, mime, and drama. Personal Discovery activities included swimming and team-oriented games.

Teenagers could choose between the Culture Enrichment Camp and the Sports Camp. In the Culture Enrichment Camp, participants put on skits and dances, had a cookout, attended a presentation by the World Federation of the Deaf Youth Section, and toured museums and other sites in Washington, D.C. Campers who attended the Sports Camp played volleyball, basketball, and soccer for half of the day and then joined the Cultural Enrichment campers in the afternoon.

Through activities, all the campers were exposed to international deaf leaders, artists, and many different cultures. Through Personal Discovery activities, campers gained self-confidence, learned the value of respect and teamwork, and developed listening and leadership skills.

Deaf Way II young attendees who did not register for the Youth Program still had fun at the Kids' Fun Center, held nightly in a corner of the International Deaf Club. There they met and made friends with children who attended the Youth Program during the day.

Deaf Way II staff worked hard and planned many of the activities a year and half in advance to ensure that all the campers would have a valuable learning experience while having lots of fun! We hope that the campers took their experiences home with them and will be inspired to become future deaf leaders. Maybe they'll be leaders, professionals, and artists!

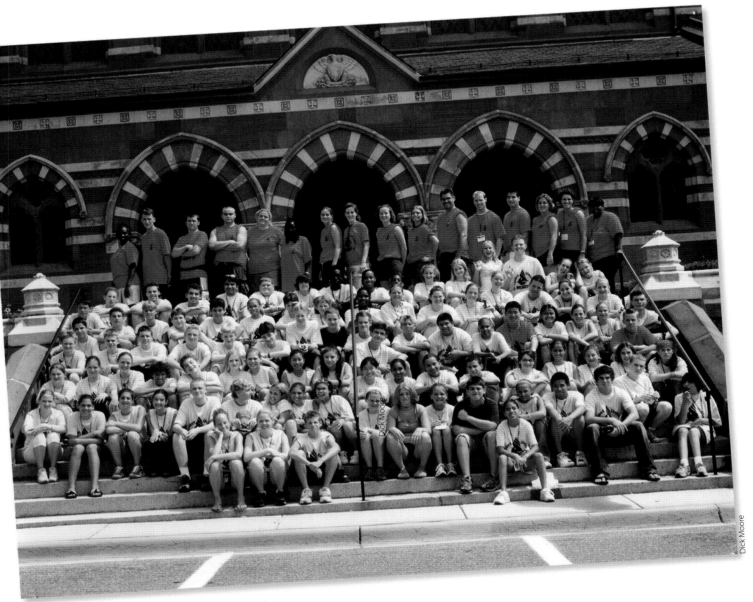

| The Teen Program participants and counselors

Dick Moore

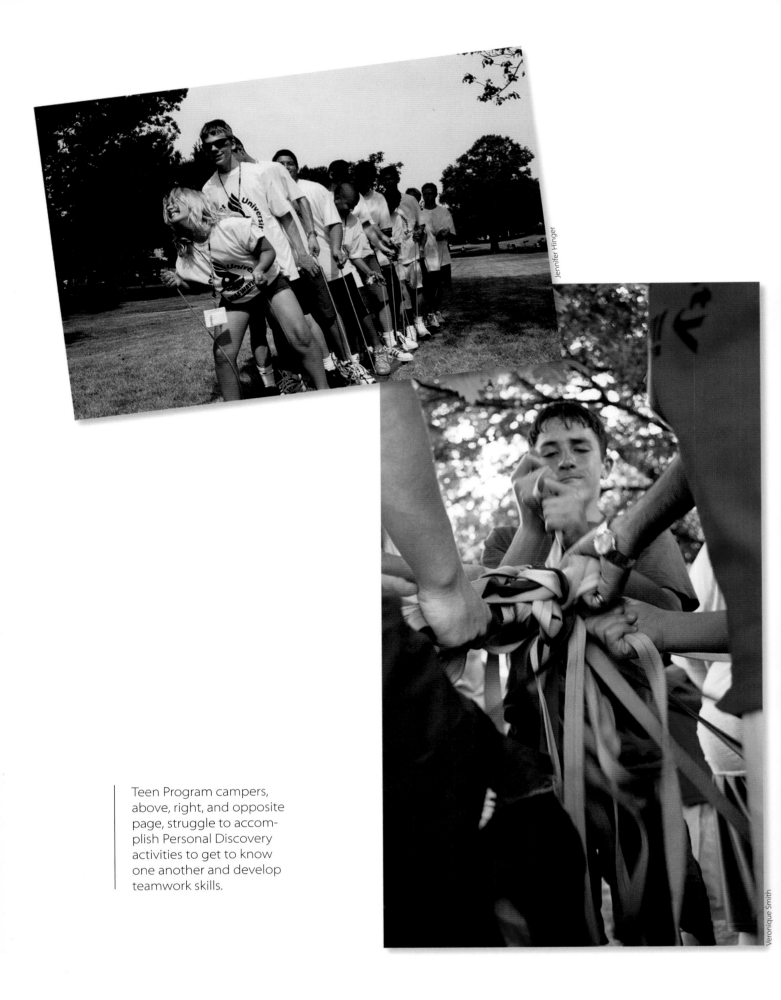

Jennifer Hinger

Veronique Smith

Teen Program campers, above, right, and opposite page, struggle to accomplish Personal Discovery activities to get to know one another and develop teamwork skills.

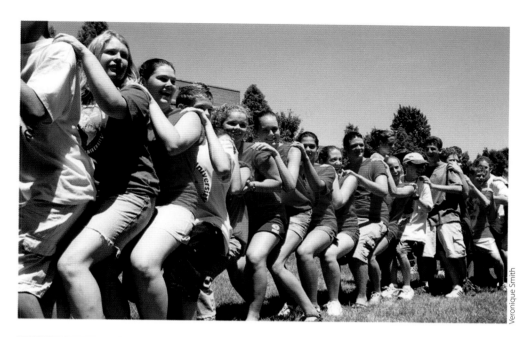

Veronique Smith

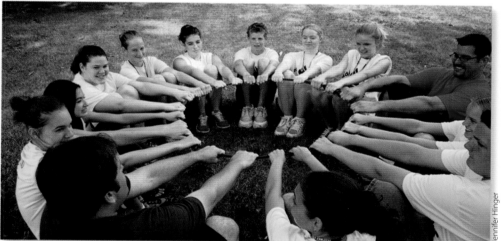

Jennifer Hinger

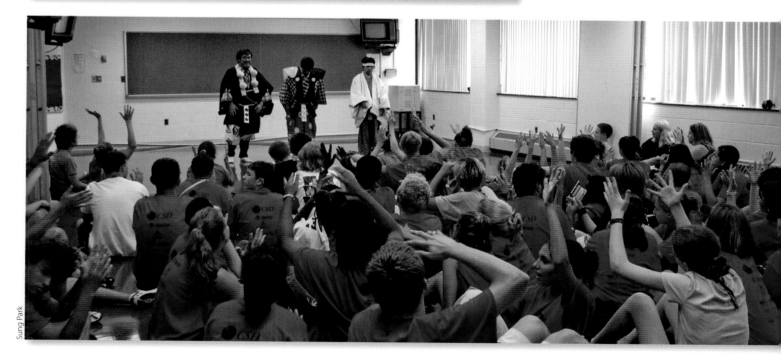

Sung Park

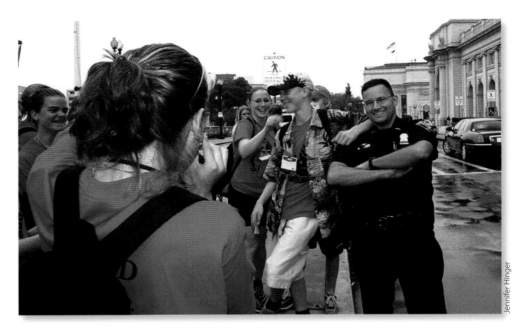
Jennifer Hinger

Deaf Way II Teen Program campers, above, pose for pictures with a D.C. police officer who is also a Gallaudet sign language student.

Campers take a tour around Washington, D.C.

Jennifer Hinger

Jennifer Hinger

Jennifer Hinger

Jennifer Hinger

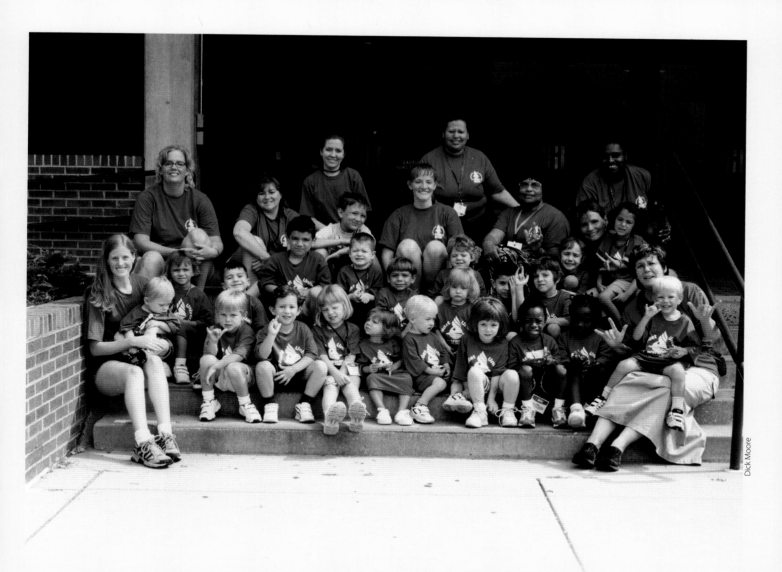

Dick Moore

The Young Children's
World Program

Jennifer Hinger

Veronique Smith

Dick Moore

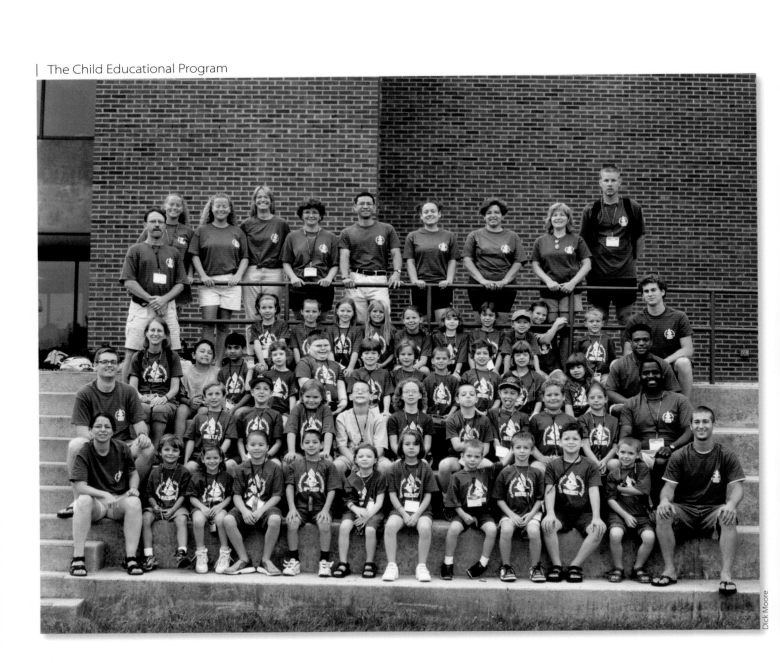

Jennifer Hinger

Jennifer Hinger

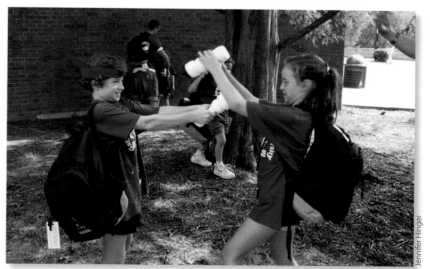

Jennifer Hinger

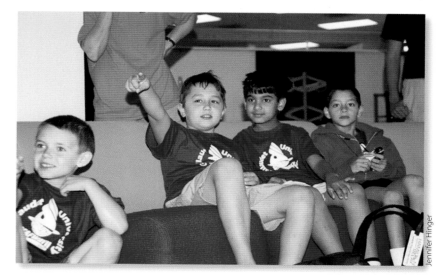

Jennifer Hinger

| The Pre-Teen Educational Program

Veronique Smith

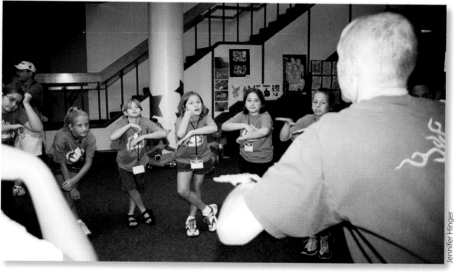
Jennifer Hinger

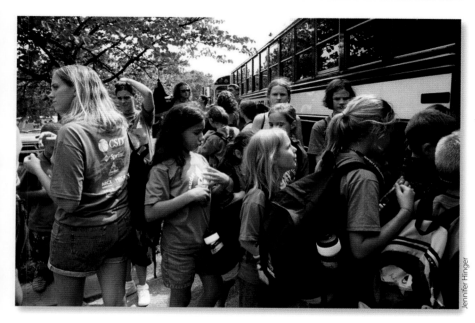
Jennifer Hinger

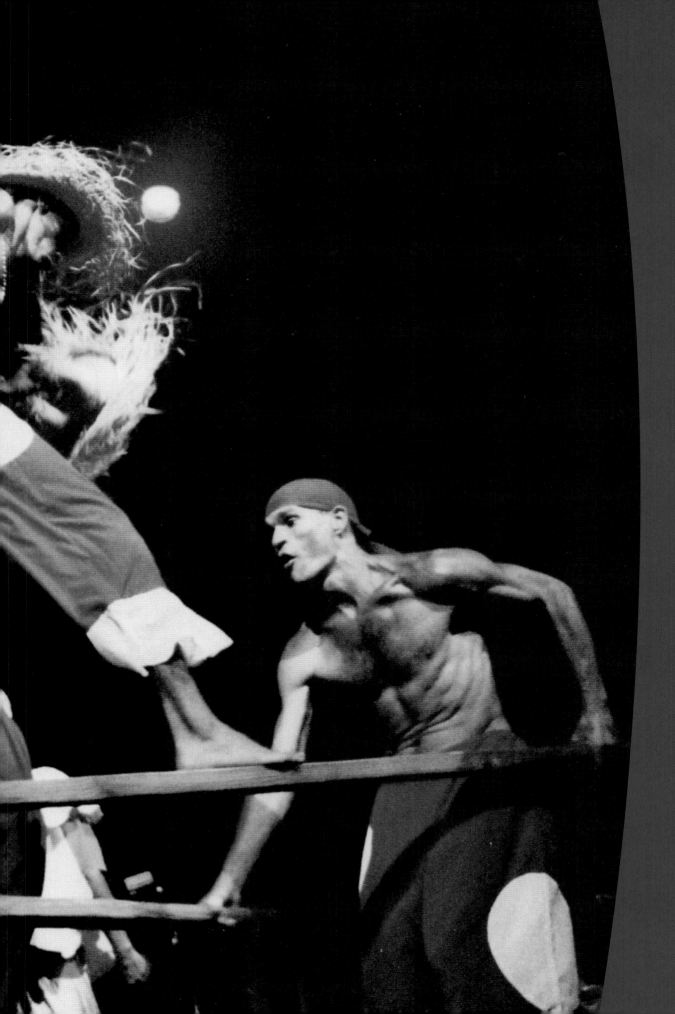

INTERNATIONAL DEAF CLUB

I n many countries, deaf clubs usually can be found in big cities with large concentrations of deaf and hard of hearing people or in towns near schools for the deaf. Many graduates from those schools continue to meet at local deaf clubs to socialize and communicate in their native sign language, catch up on news, play cards and other games, do some amateur skits and storytelling, dance, play sports, watch captioned movies, or simply sit on bar stools and drink beers.

From 1988 to 1989, former World Federation of the Deaf president Dr. Yerker Andersson surveyed national deaf organizations in nine selected countries. He found that there had been a decrease in attendance at some deaf clubs that also served as local consumer advocacy organizations affiliated with a national organization or association of the deaf. One reason for this decrease might be found in the fact that over the past few decades a significant number of deaf and hard of hearing students have been enrolled in public schools rather than in schools or programs for the deaf. For some countries, increased TV and video access at home also may contribute toward reduced attendance at deaf clubs. Nonetheless, a deaf club —or a place of social gathering of some kind— continues to exist in varying degrees within any Deaf community. At local, regional, national, or international deaf conferences, there always is a place for large

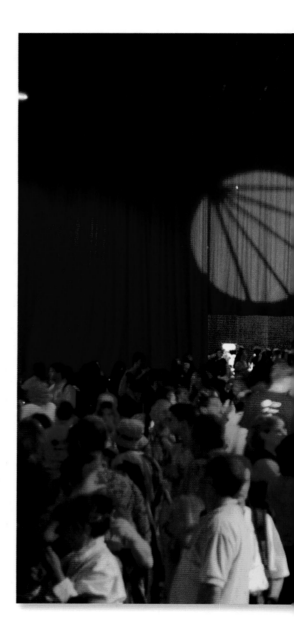

Matthew Galster

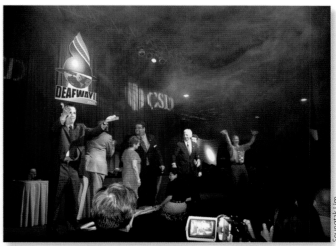

Seungtak Lim

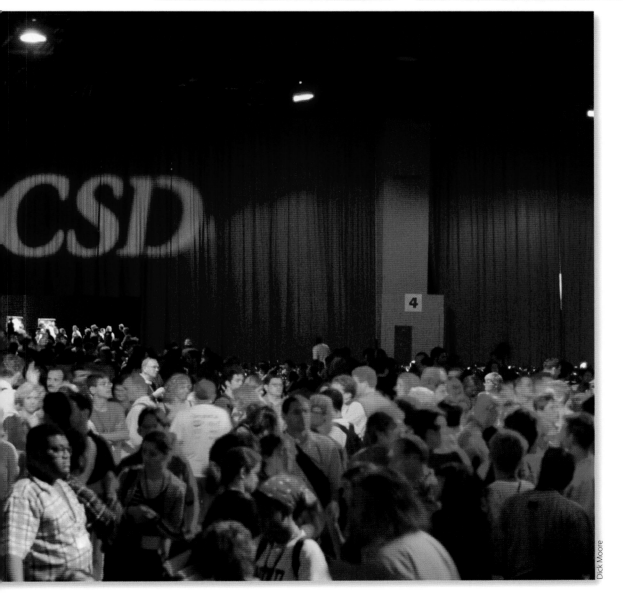

Dick Moore

Gallaudet President I. King Jordan and CSD CEO Benjamin Soukup prepare to cut the ribbon opening the International Deaf Club.

crowds to socialize, usually with added sparkle and heightened boom bam.

During Deaf Way II, the International Deaf Club (IDC) at the Washington Convention Center was the place where participants went to relax, interact, and dance each night from 8 p.m. to 2 a.m. A huge venue, as large as two football fields, the IDC had more than enough room for everyone to move around, grab some food, get something to drink, or to take their kids over to the children's area where they could jump on a moon bounce, play ping-pong, or check their e-mail or their favorite web site. The main stage and the two smaller stages featured continuous performances by many Deaf Way II artists as well as other amateur performers, which were projected on to six huge video screens placed around the room. Music pumped through amplifiers so powerful that their volume had to be turned down to one-fourth their full power. Swinging lights illuminated hanging drapes displaying the logo of CSD, the exclusive sponsor of the IDC.

The international participants appeared to communicate effortlessly with one another, by using borrowed signs or signing out visual images on the fly, using body language and facial expressions. Some even conversed using only one hand, holding a full drink in the other! Their radiance showed how much they enjoyed learning and using different native signs and experiencing different cultures, as if communication obstacles due to language differences did not exist. As IDC Chair Sherry Duhon remarked, "There are no differences here. It's all one people. I can see that everyone is happy and having a great time!" It was small wonder that well over 5,000 Deaf Way II participants of all ages packed the IDC every night to celebrate the diversity of the global Deaf community.

| Attendees dance the night away.

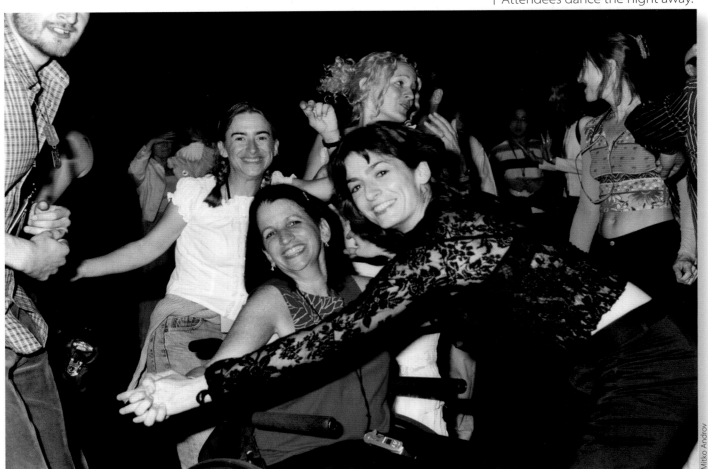

Mitko Androv

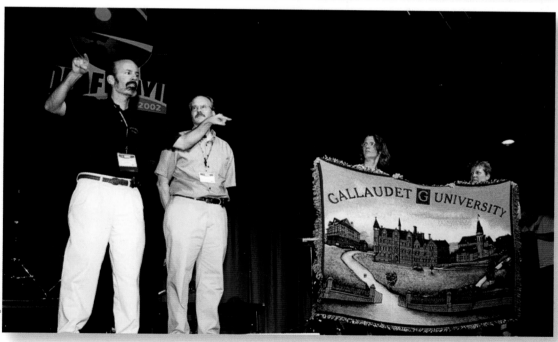

Children and adults, top, watch one of the many performances at the International Deaf Club.

Gallaudet University Alumni Relations Director Sam Sonnestrahl, far left, announces the winner of the Gallaudet banner.

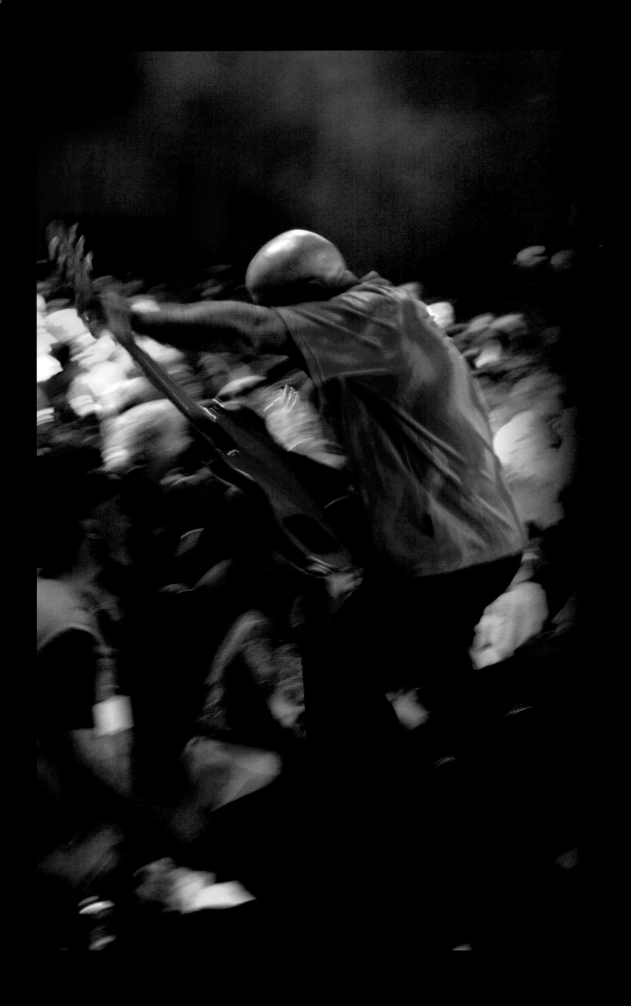

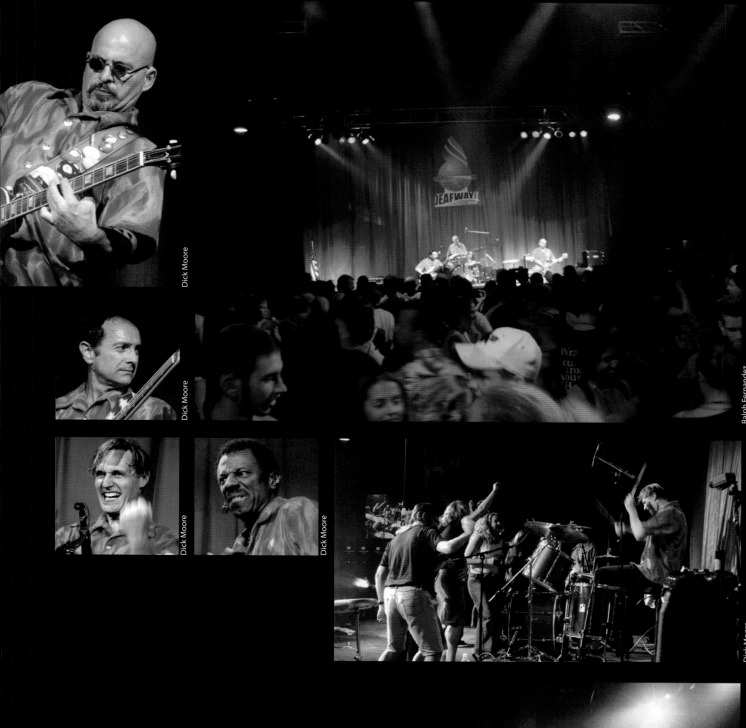

Dick Moore

Ralph Fernandez

Dick Moore

Beethoven's Night-
mare, an all-deaf band,
dazzles the crowd.

Rita Struabhaar

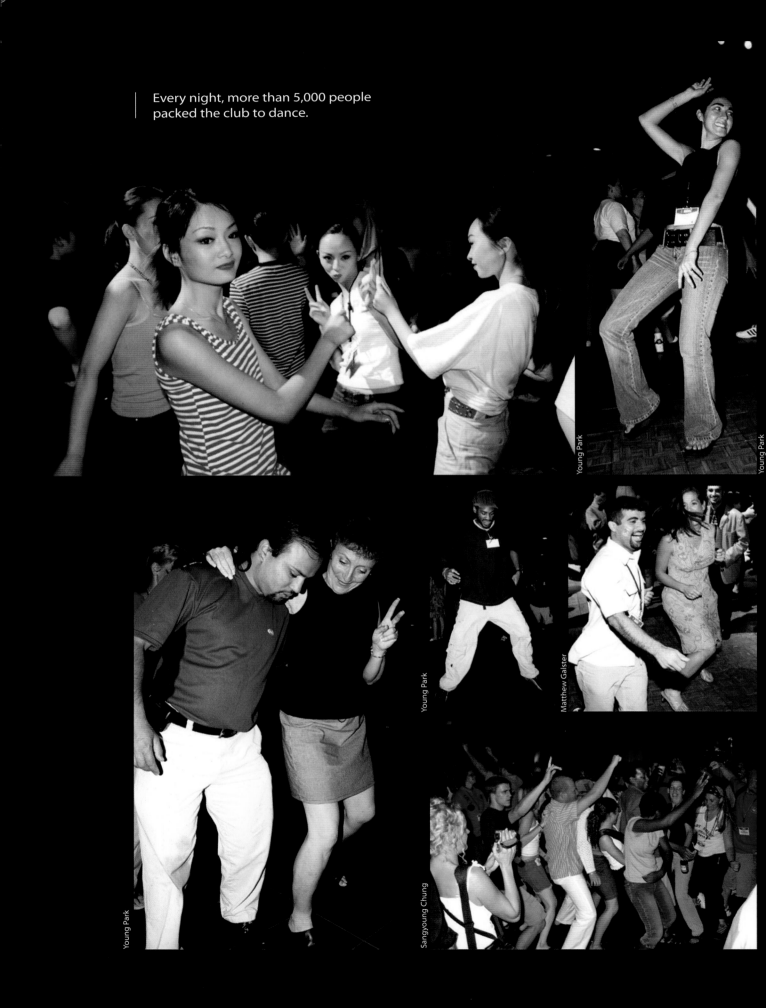

Every night, more than 5,000 people packed the club to dance.

Young Park

Young Park

Young Park

Young Park

Matthew Galster

Sangyoung Chung

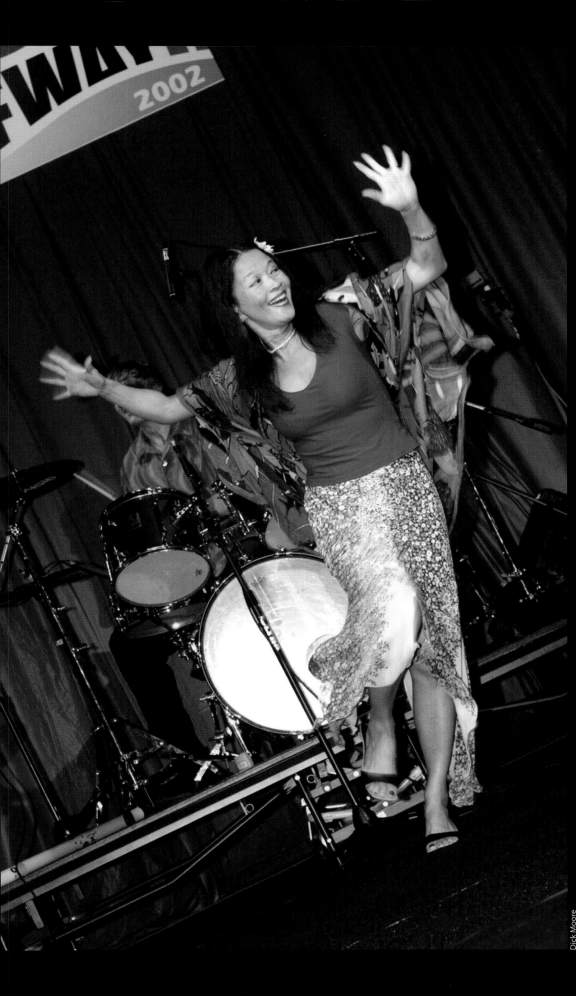

2002

A group of performers from Hawaii show off their hula dancing skills to the delight of the audience.

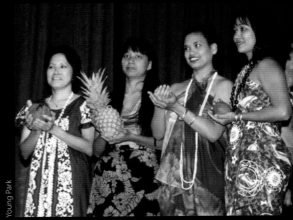

Young Park

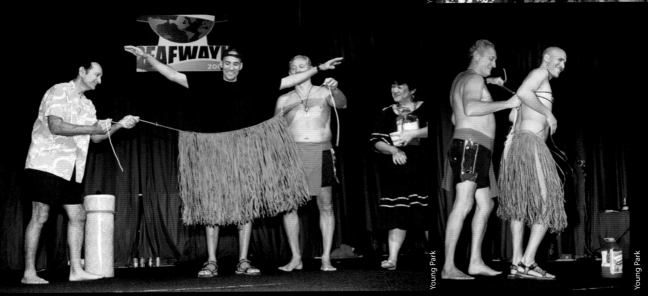

Young Park

Young Park

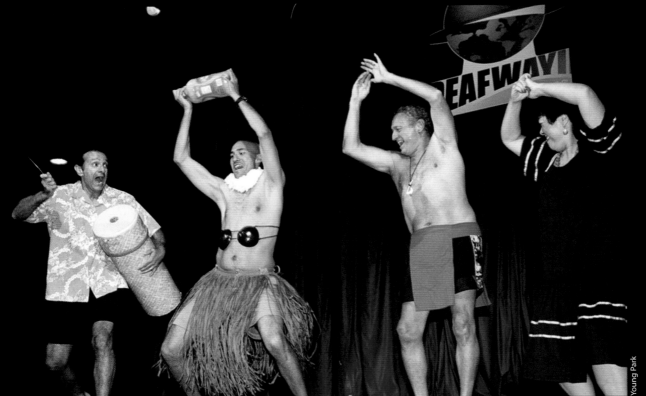

Young Park

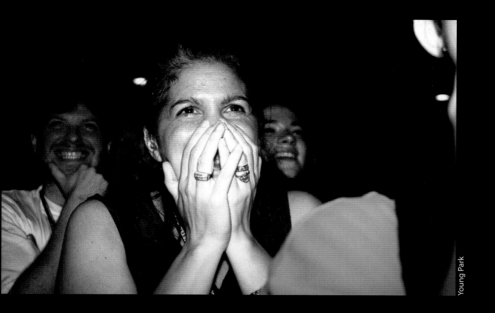

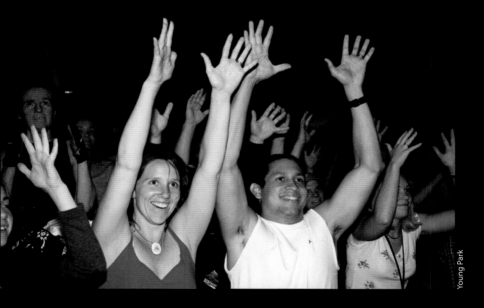

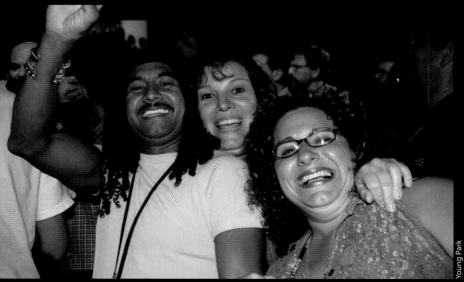

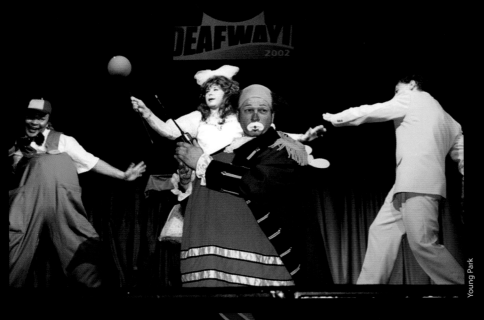

Many arts festival performers, such as Russia's Toys Theatre, top, and Cuba's ANSOC dancers, middle and bottom, also entertain the International Deaf Club audience.

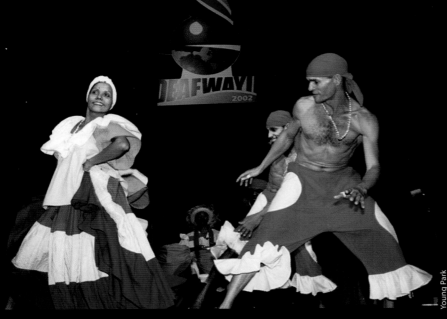

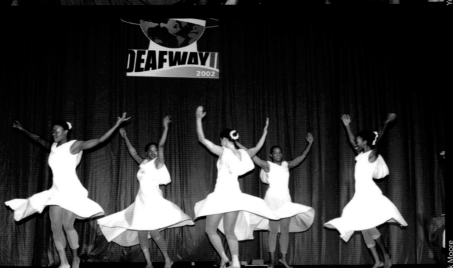

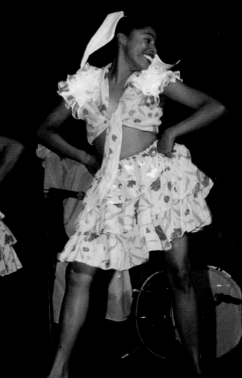

Despite the differences in languages, participants found ways to communicate and connect.

Young Park

Young Park

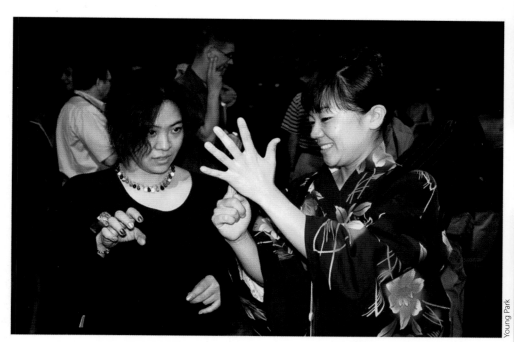

Young Park

Young Park

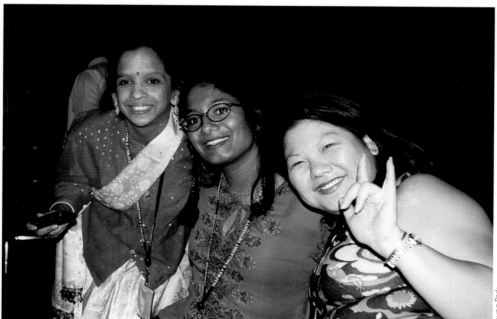

Young Park

The International Deaf Club has something for all ages.

The Kid's Fun Center, part of the nightly club, contains a playground area and plenty of games.

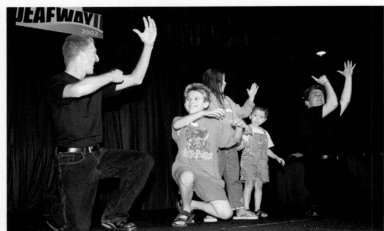

Young Park

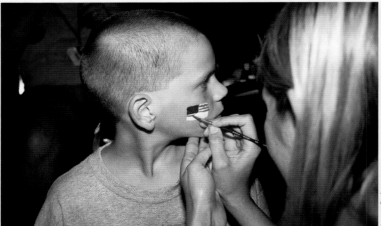

Young Park

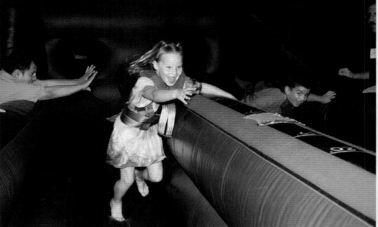

Young Park

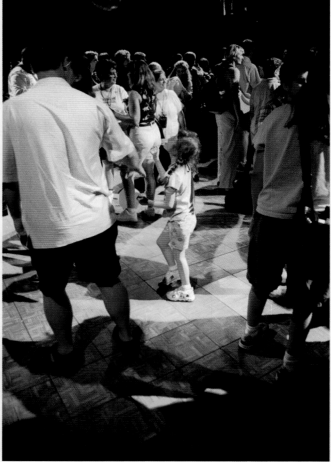

Allen Matthews

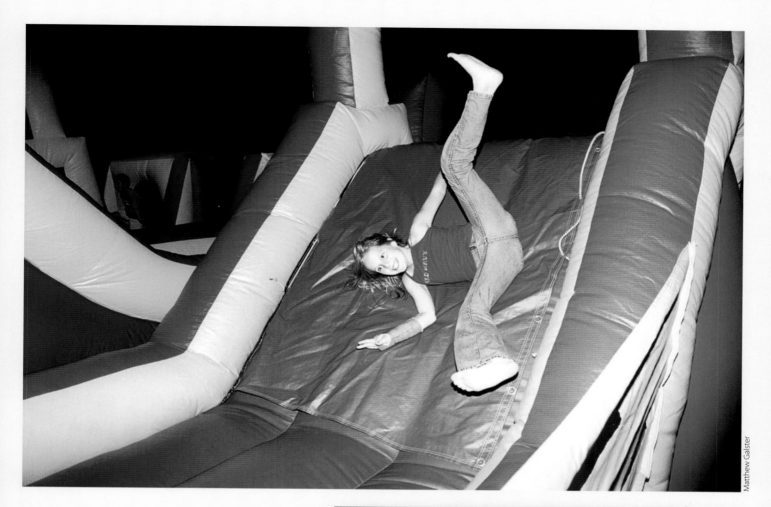

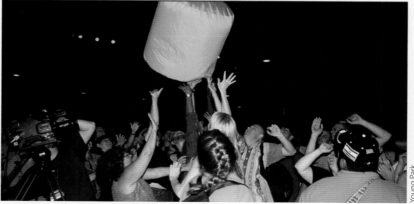

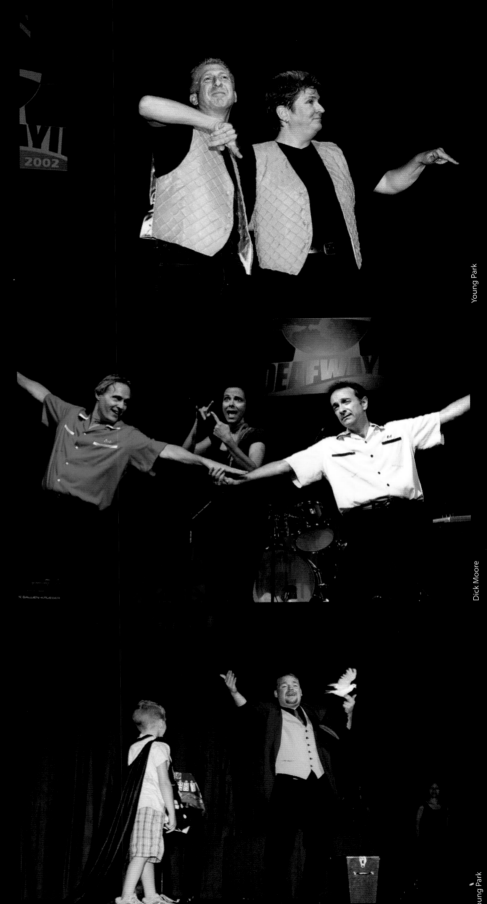

Michael Velez and Sherry Hicks, top, perform their CODA Spirit Tour. Beethoven's Nightmare, middle, rocks the house. Michael "Magic" Morgan, bottom, brings a young volunteer to the stage to assist in his magic act.

Many people met new friends and
became reacquainted with old ones at
the International Deaf Club.

Young Park

Young Park

Young Park

Young Park

Dick Moore

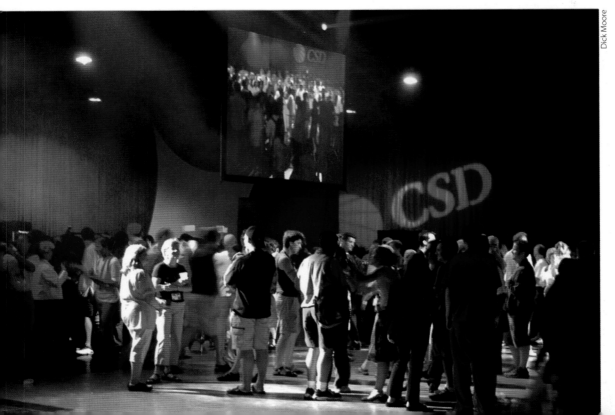

Theo & Vincent
Handtheater
(Netherlands)

FOR YOUR INFORMATION

Countries:
As of Wednesday, July 10, there are approximately 9,500 people who have registered for Deaf Way II from 109 different countries!

Internet

1:16 AM

Office

Microsoft

ACCESS

For deaf and hard of hearing individuals, issues concerning access usually center on communication and telecommunications. Starting in the early 1990s, a number of significant federal laws were passed in the United States —such as the Americans with Disabilities Act (ADA) of 1990, the Television Circuitry Decoder Act of 1990, and the Telecommunications Act of 1996— that greatly enhanced communication and telecommunications access in schools, workplaces, homes, local government agencies, and places of public accommodation in America. The ADA, for example, requires state legislatures and agencies to provide interpreters upon request by a deaf or hard of hearing person. The Telecommunications Act of 1996 called for a schedule to increase the number of closed-captioned new TV programs from 25 percent in the year 2000 to nearly 99 percent by 2006. At Deaf Way II, deaf and hard of hearing people from outside the United States had the opportunity to learn about these statutes and to be inspired to push for similar mandates in their countries.

The ADA also requires that the host organizations for national, regional, or local conferences in the United States provide reasonable accommodations if requested by deaf and hard of hearing participants. What if the deaf and hard of hearing attendees come from different countries? Communication access has always been a challenge at international meetings because of the many languages. The World Federation of the Deaf uses three official languages at their conferences: the host country's sign language,

International Sign (standardized signs and grammar derived mostly from European sign language), and written or spoken English. Most international conferences follow a similar model. Thus, Deaf Way II used American Sign Language (ASL), International Sign, and written or spoken English as its three official languages.

International Attendees
The Interpreting Committee for Deaf Way II arranged for every presentation to be held in ASL, International Sign, and spoken English. Real-time captioners also projected the presentations in written English on to large screens. However, many international conference participants did not know any

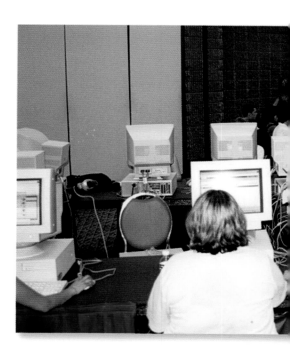

of these languages. Some groups, therefore, brought their own interpreters to translate spoken English into their native sign languages. Conversely, some international presenters brought interpreters so they could make their presentations in their own language and have their interpreters translate the presentations into spoken English. Successive interpreting then would be done in the other official languages.

Another committee, the Developing Nations Support Service (DNSS), held walk-in orientations every morning at the Washington Convention Center to assist international participants in picking presentations relevant

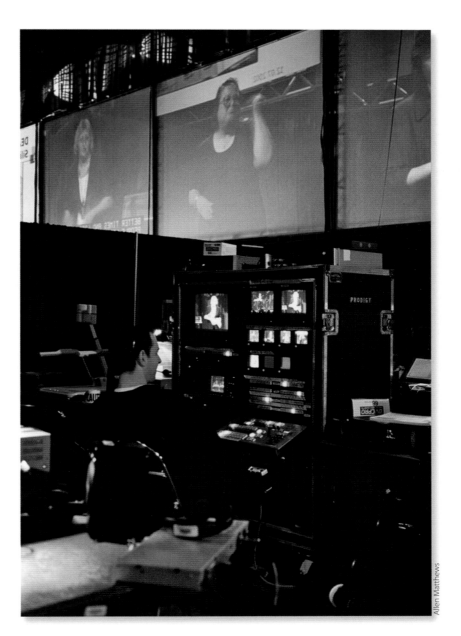

Allen Matthews

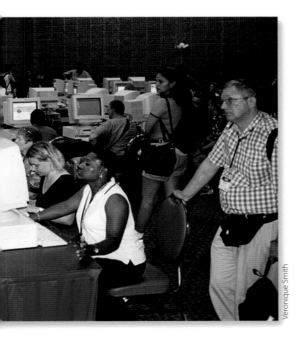

Veronique Smith

A technician monitors video and slide projectors behind the stage during a presentation.

People wait their turn at the Internet Café.

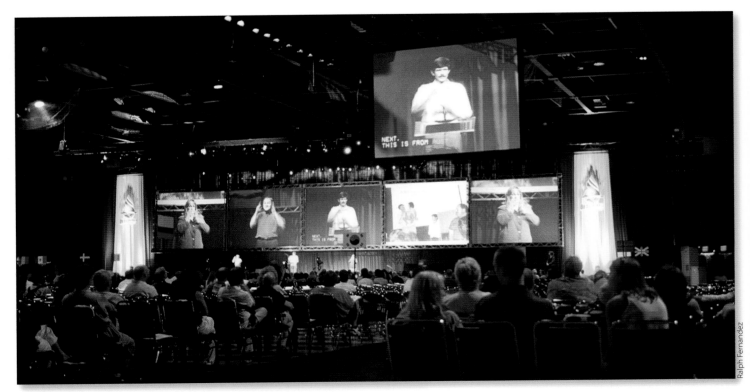

Ralph Fernandez

Veronique Smith

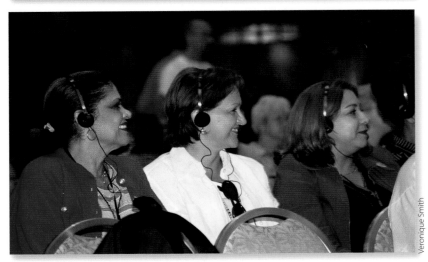

Veronique Smith

Interpreters signing in different languages, top, are projected on giant screens on either side of Rune Anda to supplement his presentation. A captioner, middle, transcribes a workshop.

Hearing participants enjoy workshops via headphones.

Tactile interpreters provide access for deaf-blind (tactile) conference attendees by transmitting information through fingertips and hand movements.

to their needs. They also answered questions about the arts festival, getting around D.C., and other special activities. A videotape produced by DNSS played continuously in their resource room that demonstrated some International Sign Language and key concepts by presenters.

How did attendees who came from different countries and who did not know English first learn about Deaf Way II? Before the conference, international country representatives volunteered to become their region or country's contact person and to spread the word about the conference and arts festival in their own languages. They passed out translated materials and assisted people in filling out the registration forms in English. Some went even further and asked for permission to translate parts of the Deaf Way II web site to post on their own sites. The Deaf Way II organizers gladly gave them permission and created links from the Deaf Way II web site to theirs.

Deaf-Blind Participants

Deaf-blind (tactile or close vision) individuals made up about one percent of Deaf Way II's registrants. The Interpreting Committee provided tactile or close vision interpreting to deaf-blind attendees who requested their services at least two months in advance.

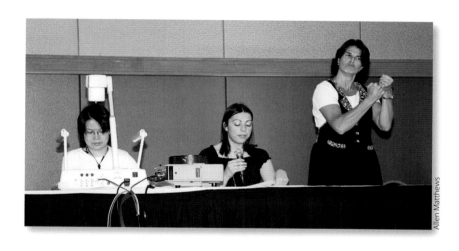

Support Service Providers were also on hand to walk around and work with deaf-blind participants during breaks, meals, and other activities. The program book was also available in Braille and in large print.

At Deaf Way II, it was evident that many deaf, hard of hearing, and hearing people worldwide supported the principle of "access for all." Thanks to such an extra collective effort, the conference was able to achieve access for practically all participants.

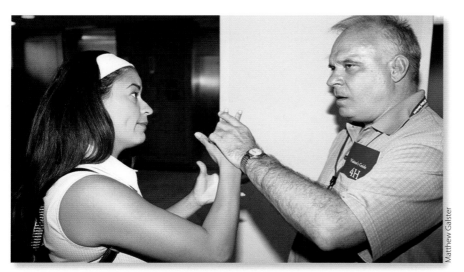

Matthew Galster

Marilyn Fernandez and Art Roehrig, top, chat in the Renaissance Hotel. A deaf-blind interpreter translates for Ryan Bondroff, center, in a Deaf and Deaf-Blind Interpreting Issues session.

Conference attendees walk past the Deaf-Blind Interpreters' Room at the Washington Convention Center.

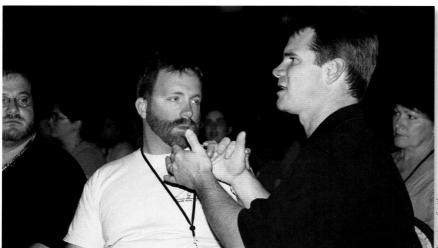

Veronique Smith

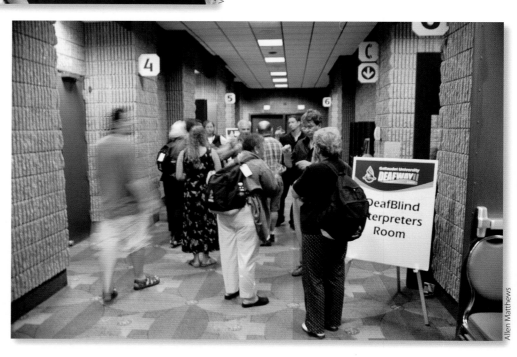

Allen Matthews

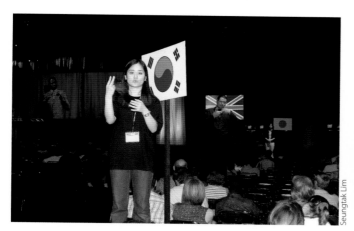

Seungtak Lim

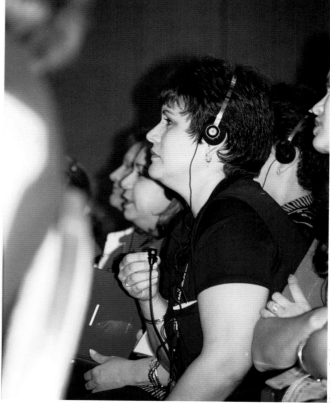

Veronique Smith

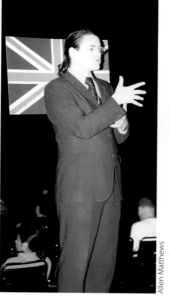

Allen Matthews

Allen Matthews

Veronique Smith

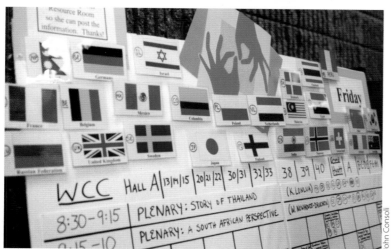

John Consoli

At Deaf Way II, interpreters from around the world are recognized as an official group for the first time. The world sign language team members interpret spoken English into their native sign languages, such as Koren Sign Language, top left, Japanese Sign Language, middle left, and British Sign Language, middle right.

A young man, above right, with a twenty-first-century hearing aid—all spiked metal—catches the eye of many. The international interpreter schedule board, left, shows the multitude of countries represented at Deaf Way II.

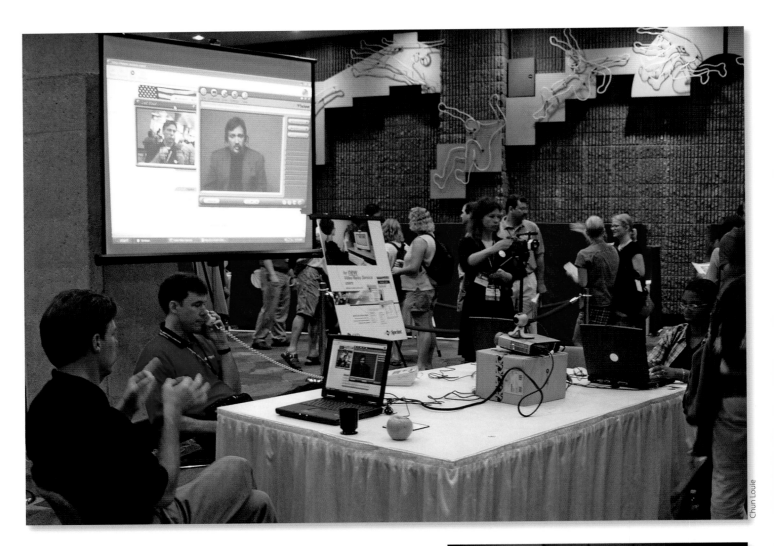

Chun Louie

Ralph Fernandez

A demonstration of video relay service takes place at the Washington Convention Center, above. This service enables a deaf person to communicate with a hearing individual or vendor through an interpreter (on video) who translates sign language into spoken language and vice versa.

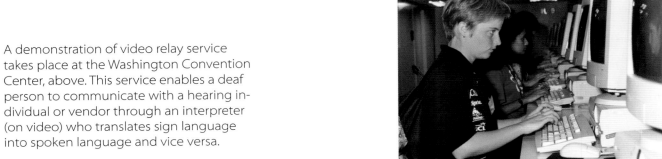

Mirko Androv

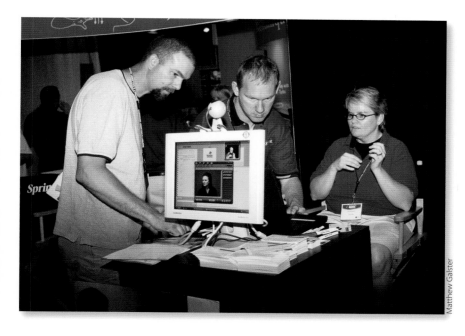

Matthew Galster

Both CSD and Sprint exhibit videocam technology that allows participants to chat online with family and friends via a video camera attached to a computer.

Young Park

Ralph Fernandez

Ralph Fernandez

Two-way pagers and other technologies that enhance communication access are on display in the Exhibit Hall.

Ralph Fernandez

Seungtak Lim

Veronique Smith

Marla Moffet

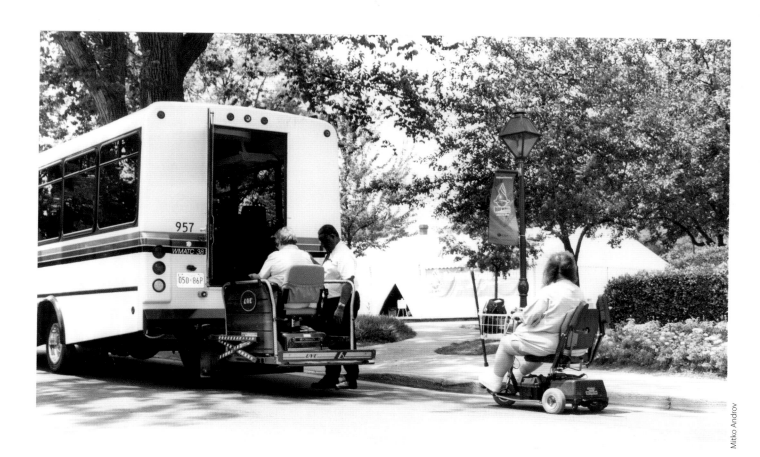

Deaf Way II participants, above, await their turn to ride the shuttle back to the Washington Convention Center from Gallaudet University.

Dana the Wonder Dog, a certified hearing dog, high-fives her owner Cheryl Heppner.

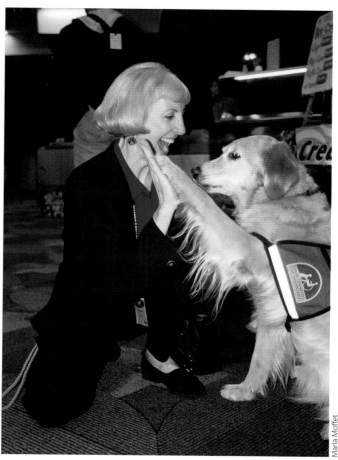

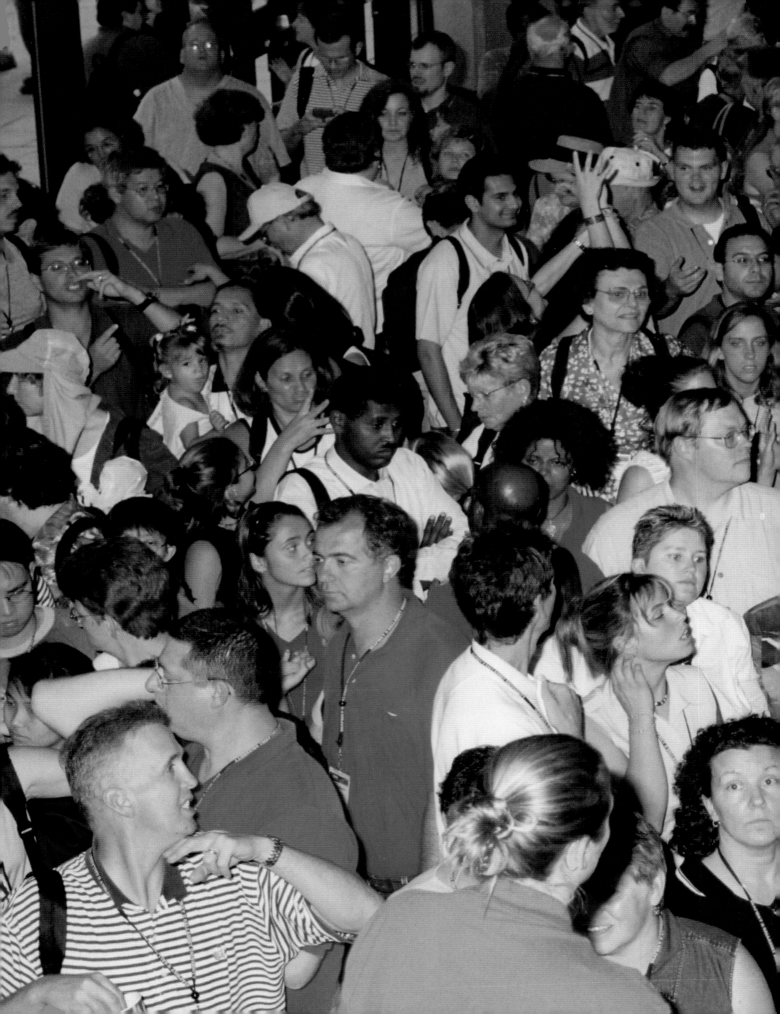

PEOPLE

ven before registration opened at 7:30 a.m. on the first day of Deaf Way II, thousands of people already waited in line at the Washington Convention Center to register! That first day of registration "was like a total madhouse," said Anjali Desai-Margolin, co-coordinator of the Deaf Way II Registration Committee. "The numbers exceeded way over our expectations." The registration staff, nearly all deaf, rose to the challenge and did a wonderful job moving the huge crowds through the process despite language differences. The participants were even more impressive, patiently and good-naturedly waiting in line, some for more than two hours. Many people used this time to get reacquainted with old friends or to make new ones. By the initial close of registration, nearly everyone had been handed name badges and backpacks.

Who were these thousands of people who came to Deaf Way II and why did they come? Most attendees were deaf or hard of hearing; however, hearing colleagues, family members, and friends of deaf people also attended. Many people came eager to learn about and appreciate different cultures, sign languages, customs, and services. Parents brought their deaf children to expose them to successful deaf adults and leaders, to show them what they could accomplish, and to enable them to feel good about themselves. Researchers shared findings during the presentations. Professionals met to form information networks and support groups. Art lovers came to see the best in deaf theater and art from all over the world. No

other event has brought together so many deaf artists. Some people came to socialize and dance at the International Deaf Club every night.

Other participants saw Deaf Way II as an opportunity to increase access and opportunities for deaf people back home by enlightening individuals in positions of power. At the time of Deaf Way II, the Swiss Parliament was formulating and rewriting their Equity Act—a mandate equivalent to the Americans with Disabilities Act. A group of Swiss Deaf Way II attendees invited Suzanne Blickenstorfer, the wife of Switzerland's ambassador, to conference presentations and the Exhibition Hall to expose her to deaf people's accomplishments and to show her available technology such as video relay. Nigerian leaders and educators Kehinde Akewusola and Odutola Odusanya came to Deaf Way II seeking volunteers to serve as role models in Nigeria and to help influence and inspire those in charge of their country's deaf education to improve the curriculum.

Deaf Way II even affected people who did not directly participate. News stories about Deaf Way II appeared in local, national, and international media outlets before, during, and after the event. The Deaf Way II web site (www.deafway.org) posted video clips and photographs so that people who could not attend could still experience and appreciate the conference and arts festival.

Deaf Way II brought a huge influx of deaf people into Washington, D.C., posing a new experience for many service industry workers. At any of the three conference hotels—the

Friends (from left) Lori Lutz, Kristen Harmon, and Susi Wilbur sign "Deaf Way II."

Actor Peter Cook leads a crowd gathered for the Deaf Studies Master's Program Kickoff Celebration in a fishing adventure.

Jennifer Hinger

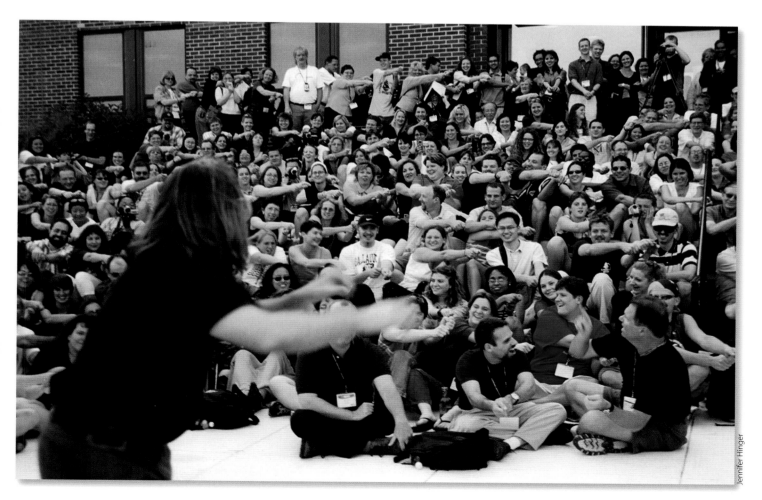

Jennifer Hinger

Cycling across the USA, a group of nineteen international cyclists and one support team member, celebrate the end of their fifty-two-day journey from Los Angeles to Washington, D.C. The ride was a fundraising event that aims to bring deaf students from developing countries to the United States to pursue college educations.

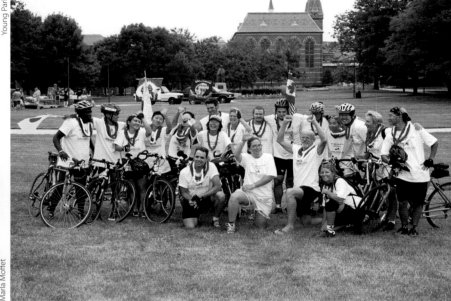

Young Park

Marla Moffet

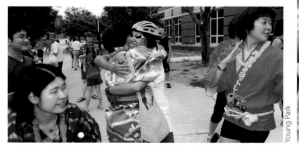

Young Park

Marla Moffet

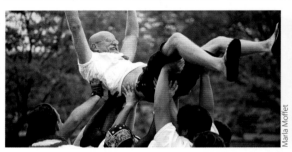

Marla Moffet

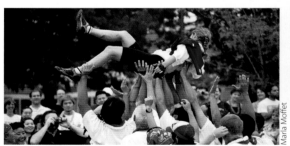

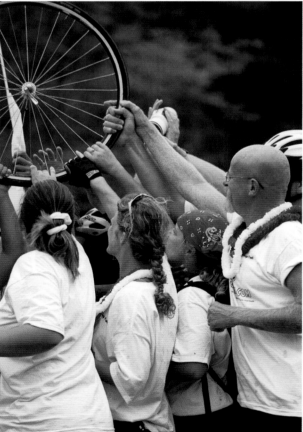

Marla Moffet

Grand Hyatt Washington, the Renaissance Washington Hotel, and the Hyatt Regency Capitol Hill—hotel front desk staff discovered that sign languages, like spoken languages, are different in many countries. Waiters in local restaurants quickly learned that saying "pardon me" behind a deaf person's back would have no effect and that tapping the individual's shoulder or arm to get attention was not considered at all offensive.

The public also saw that deaf and hard of hearing people are just as capable as hearing people are, communication differences aside. Some deaf people can sign fluently and others cannot. Some deaf and hard of hearing people wear hearing aids or have cochlear implants while others do not. Deaf Way II encouraged experiences and exposure among everyone, and provided strategies and inspiration to improve the quality of life for deaf and hard of hearing people worldwide.

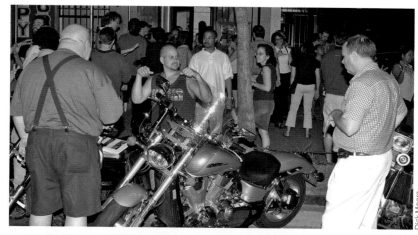

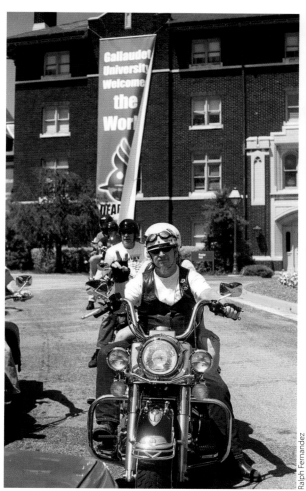

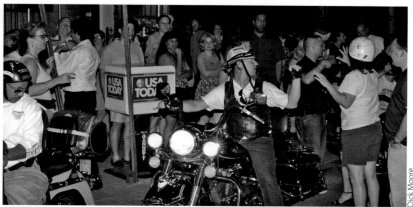

Deaf bikers meet up at the Deaf Professional Happy Hour event and enjoy other Deaf Way II events.

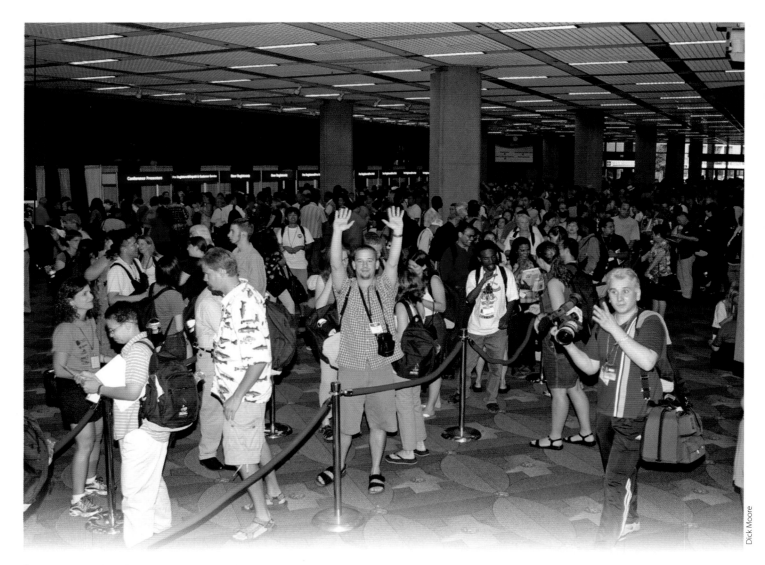

| Huge crowds of people arrive the first day for registration.

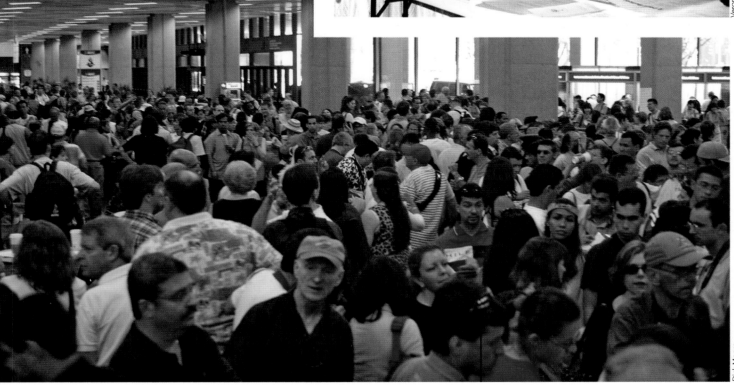

Buses shuttle participants between the events in downtown D.C. to the events at Gallaudet University every fifteen minutes. President Jordan, right, leads a tour of the Gallaudet campus.

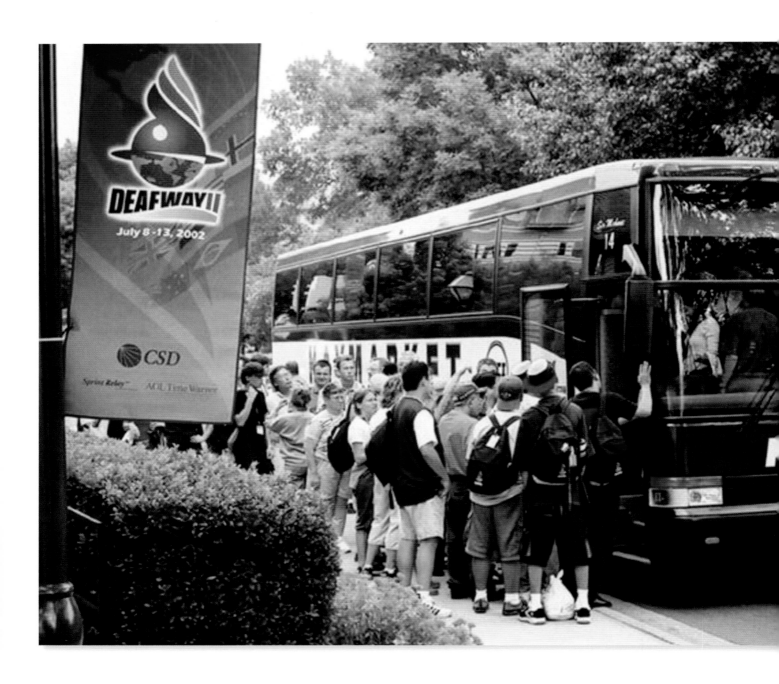

Veronique Smith

Allen Matthews

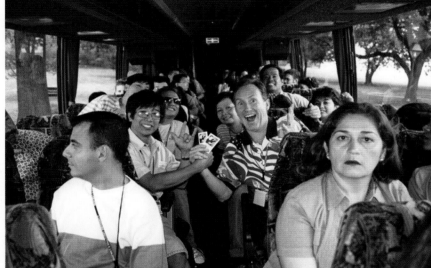

Marla Moffet

Jennifer Hinge

Dick Moore

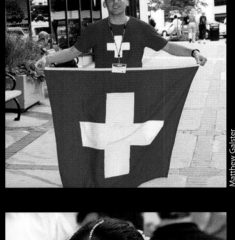

Matthew Galster

Mitko Androv

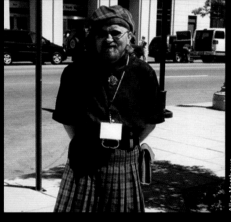

Allen Matthews

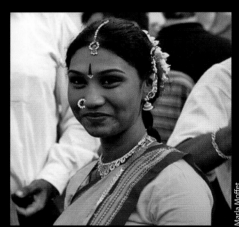

Marla Moffet

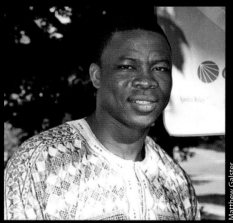

Matthew Galster

Mitko Androv

International participants came from all over the world to share their cultures, sign languages, and customs.

Jennifer Hinge

Dick Moore

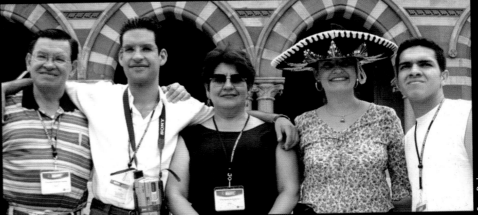

Sung Park

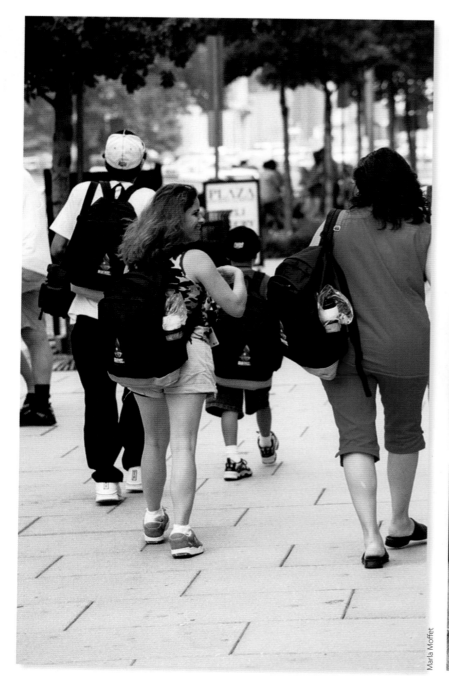

Veronique Smith

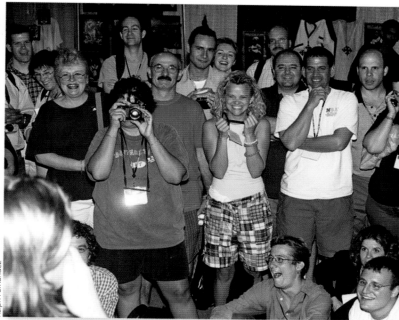

Ralph Fernandez

Sung Park

Young Park

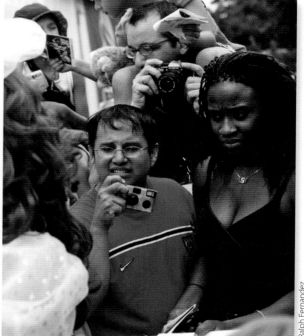

Ralph Fernandez

Sung Park

Dick Moore

Veronique Smith

Deaf Way II isn't just for adults. Many children accompanied their parents to performances and art exhibits.

Veronique Smith

Marla Moffet

Jennifer Hinger

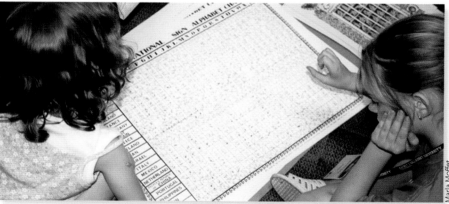

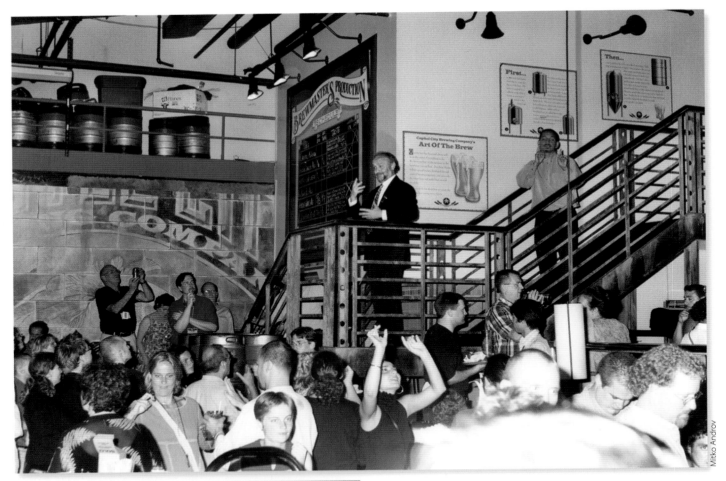

Mitko Androv

Mitko Androv

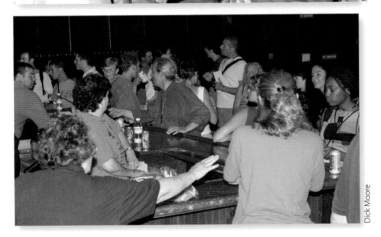

Dick Moore

The Cultural Arts Committee party, above.

Dick Moore, left, in a good-natured discussion with Rita Corey.

The Capitol City Brewing Company restaurant, below left, welcomed that large influx of its Deaf Way II customers.

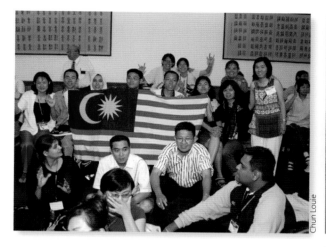

The Greater Washington Asian Deaf Association and the National Asian Deaf Congress sponsored the "Show Our Friendship to Asia!" dinner event at the Chinese Lei Garden in D.C.'s Chinatown. Over 300 guests came together to celebrate the Asian spirit of hospitality.

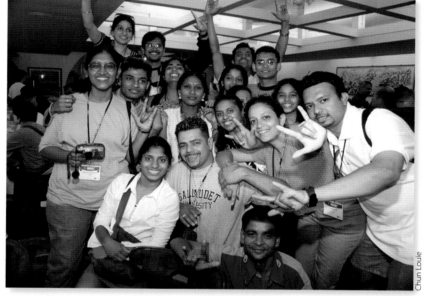

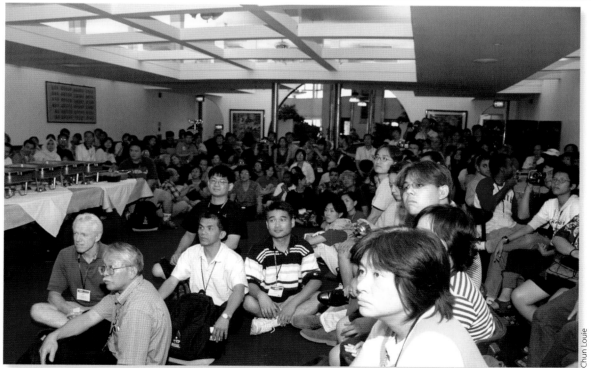

Maria Moffet

Maria Moffet

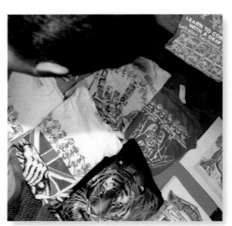

Young Park

Matthew Galster

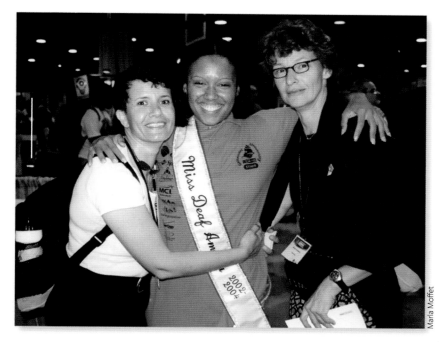

Maria Moffet

Allen Matthews

Jennifer Hinger

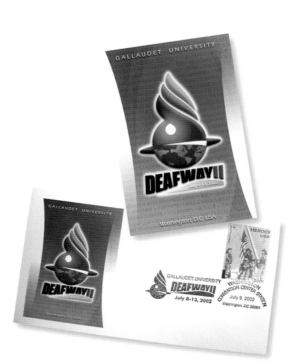

Jennifer Hinger

Allen Matthews

Chun Louie

Dick Moore

Young Park

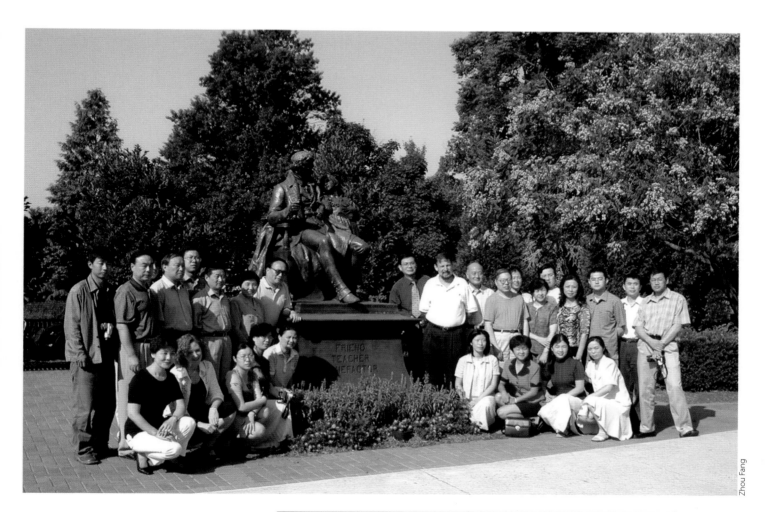

Zhou Fang

Dick Moore

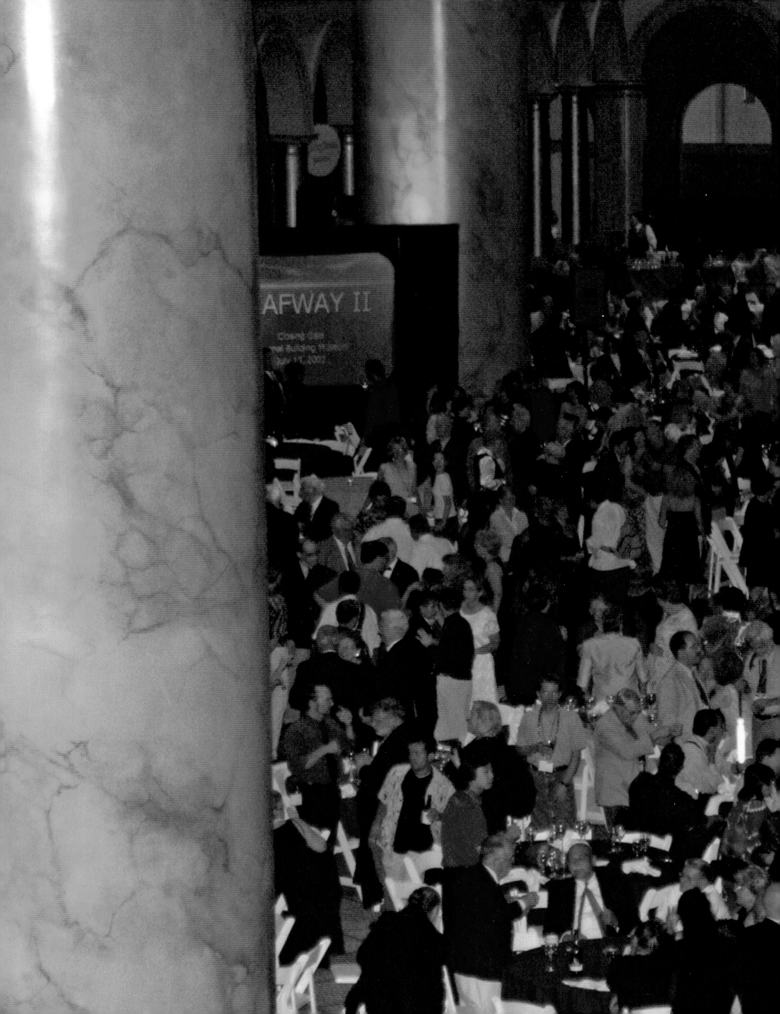

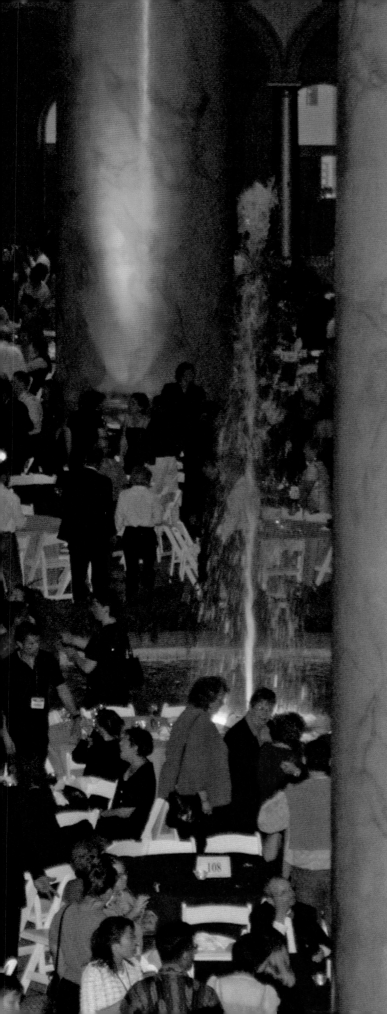

CLOSING BANQUET

CLOSING BANQUET

The grand finale of Deaf Way II featured a night of dinner and dancing in the historic National Building Museum's elegant Great Hall. The impressive Italian Renaissance design, with a central water fountain and eight colossal Corinthian columns, has made the Great Hall a sought-after spot for gala events, including many presidential inaugural balls. In 1988, Gallaudet University President I. King Jordan's inaugural ball was held there. It seemed a fitting place for the Deaf Way II Closing Banquet.

Attendees shed the shorts and tennis shoes they had worn during the week and dressed up in formal or semi-formal attire. Some international participants wore traditional clothes from their countries, including one banquet-goer who wore a colorful three-piece outfit of West African design.

The event, which lasted from 7 p.m. until midnight on Saturday, July 13, included music and dancing, a video presentation of the week's highlights, and a short closing program emceed by Bob Daniels. As the evening came to a close, a toast was made thanking everyone for their attendance, participation, and support, which made Deaf Way II a successful celebration of deaf and hard of hearing people's capabilities and accomplishments and an inspiration for many future achievements.

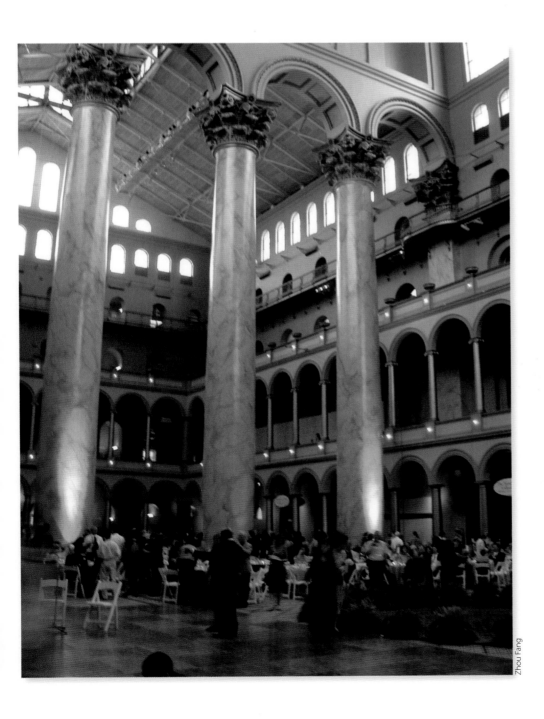

Zhou Fang

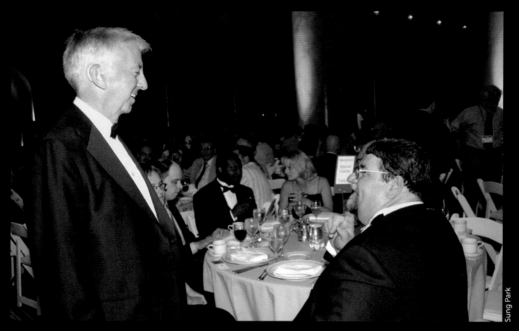

Sung Park

Gallaudet University President I. King Jordan, above, chats with CSD CEO Benjamin Soukup before dinner.

Bob Daniels, top right, entertains the crowd.

Harvey Goodstein, bottom right, asks Zhou Fang, the designer of Deaf Way II's logo, to speak about his inspiration for the design.

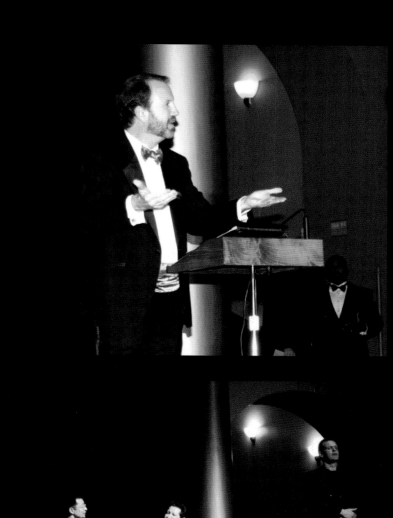

Zhou Fang

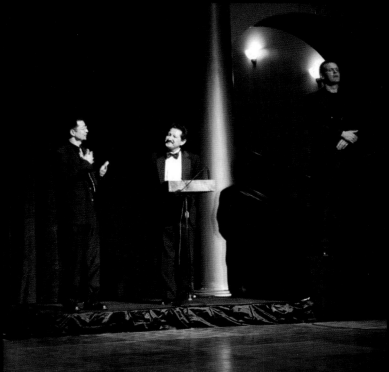

Jennifer Hinger

As the grand finale of Deaf Way II, the Closing Banquet was a wonderful way to top off the week's events.

Participants, decked out in their formal finery, enjoy the evening's festivities.

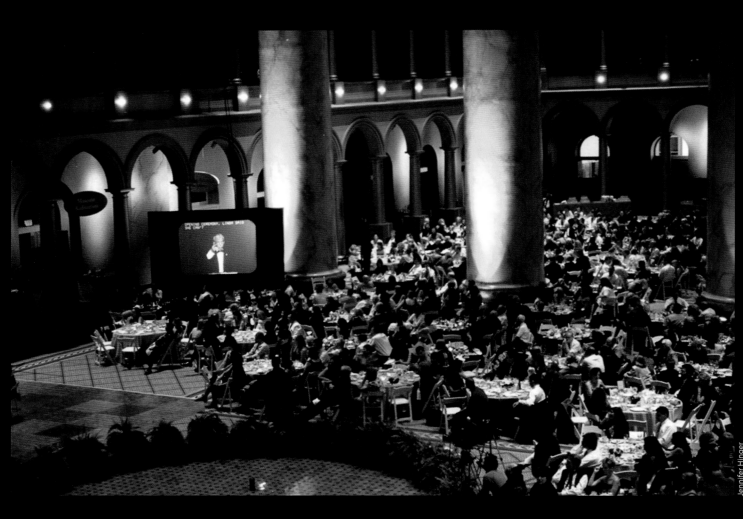

Astrid Goodstein

Lloyd Ballinger

Lloyd Ballinger

Sung Park

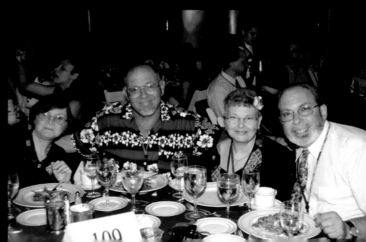

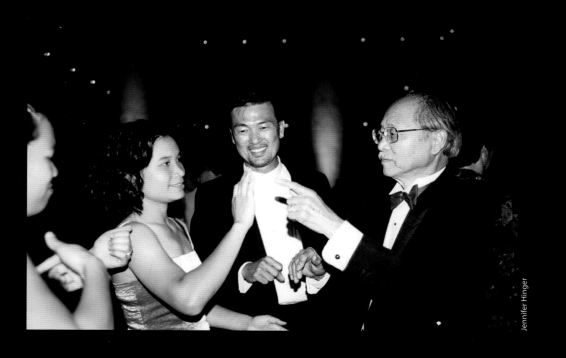

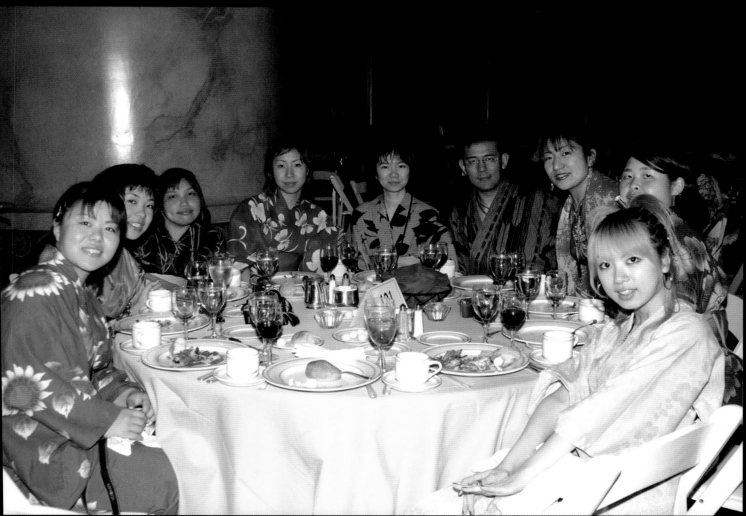

The night was full of lively banter, laughter, and dancing.

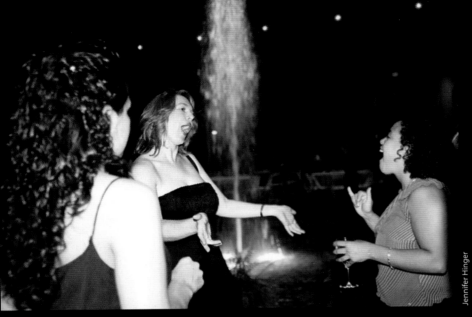

Jennifer Hinger

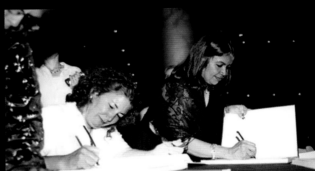

Jennifer Hinger

Jennifer Hinger

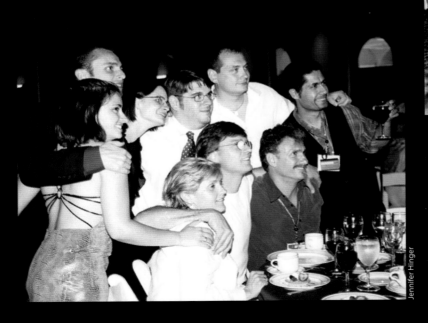

Jennifer Hinger

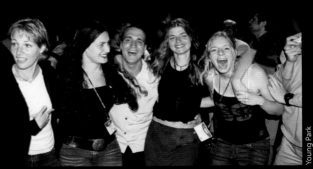

Young Park

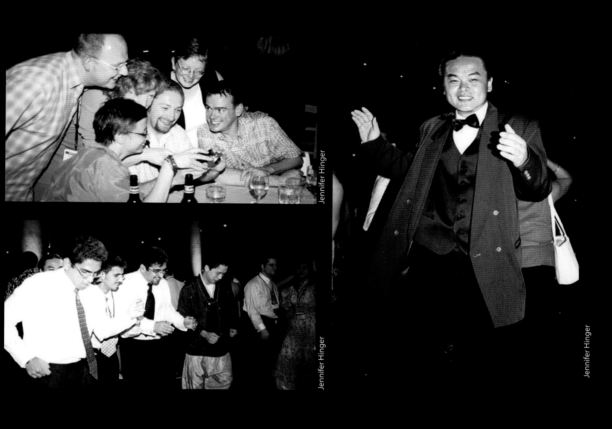

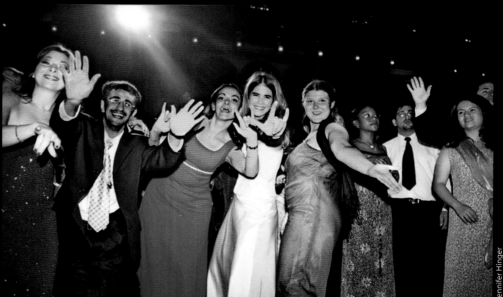

BEHIND THE SCENES

he six days of Deaf Way II seemed to come and go with the speed of an express train. However, this successful, well-coordinated conference and arts festival was the result of four years of careful planning by the Organizing Committee, the tremendous support by Gallaudet University, and the support of many other individuals, volunteers, agencies, sponsors, and partners committed to the success of this project.

Since 1998, the Organizing Committee —consisting mostly of Gallaudet University faculty, staff, students, and administrators— had been working to create an event for everyone. Guided by the vision statement, the committee began coordinating and planning every aspect of the event. The Committee chapter at the end of this book lists the Organizing Committee's coordinators, subcommittees, and consultants as of July 2002 to give the reader some sense of the wide variety of logistical work and screening processes involved.

One big challenge for the Organizing Committee was attracting a good number of international participants, including those from developing countries, under a weakening global economy and after the tragic events of September 11, 2001. To meet that goal, the committee sent thousands of posters, brochures, and registration packets to international country and regional representatives and asked them to distribute the material to as many people as possible. Rosanne Bangura, the International

Coordinator, worked closely with international contact persons who volunteered to translate the materials into their native languages. John Lewis, the Coordinator of International Affairs, met and worked with U.S. State Department representatives to make U.S. embassies around the world aware of Deaf Way II. Lewis also worked with the Immigration and Naturalization Service to simplify the visa process for Deaf Way II attendees. He then wrote more than one thousand letters of invitation to international participants. His and other committee members' efforts helped to bring more than three thousand international visitors, 32 percent of the total attendees, to Deaf Way II.

The organizers also wanted to reach as many people in the United States as possible, including those in the larger Washington, D.C., community. Deaf Way II advertisements were posted in subway stations and on buses throughout the region. The local NBC television station, a corporate sponsor of Deaf Way II, developed and broadcast a public service announcement about the event. The Washington Post and National Public Radio did interviews and stories about Deaf Way II. The Cultural Arts Subcommittee developed partnerships with local venues to showcase arts festival performances and art exhibits that the public could attend. Brochures listing these events and exhibits were widely distributed throughout the city.

Thanks to the efforts of hundreds of volunteers and all the members of the Organizing Committee and subcommittees, Deaf Way II was an overwhelming success.

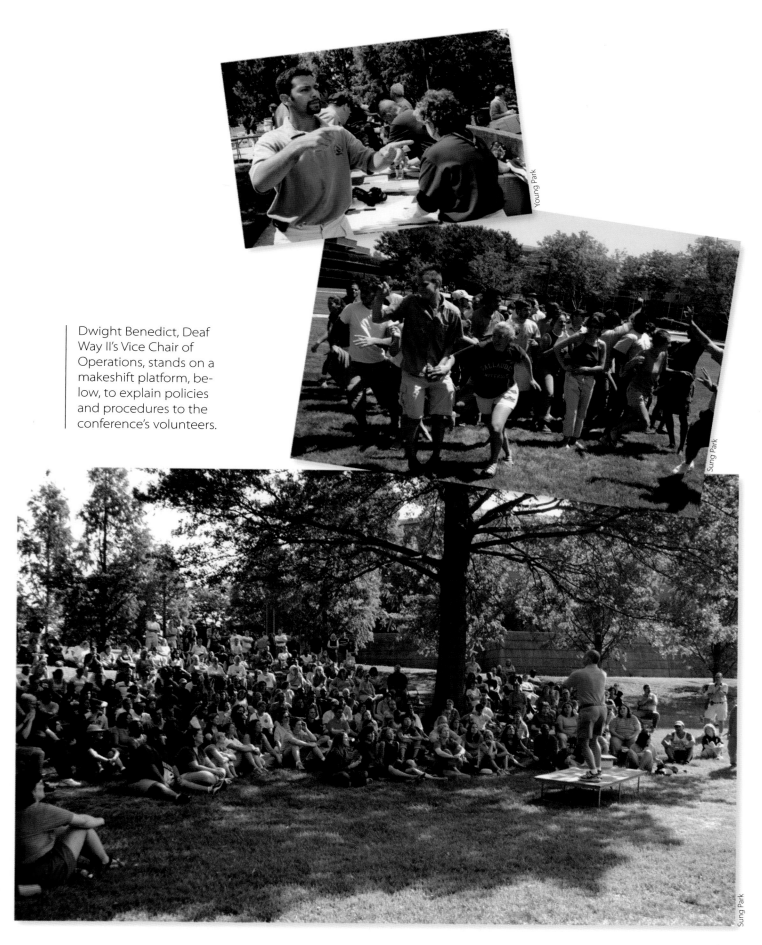

Dwight Benedict, Deaf Way II's Vice Chair of Operations, stands on a makeshift platform, below, to explain policies and procedures to the conference's volunteers.

Young Park

Sung Park

Sung Park

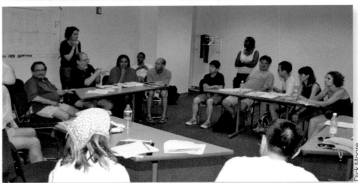

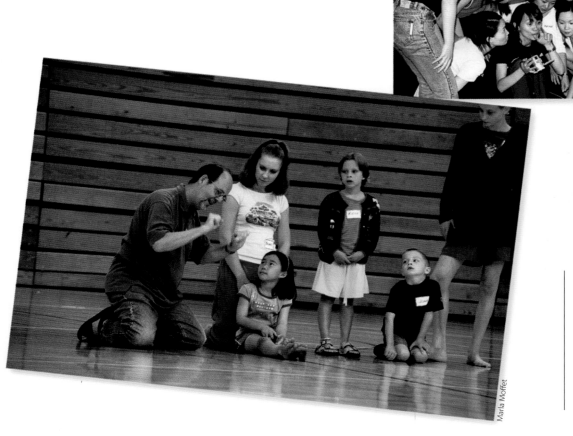

Cultural Arts volunteers, above, assist with rehearsals for the opening ceremonies. Deaf Way II Cultural Arts Producer Tim McCarty, left, rehearses "What You Believe," the Opening Celebration's song finale, with some of the youngest performers.

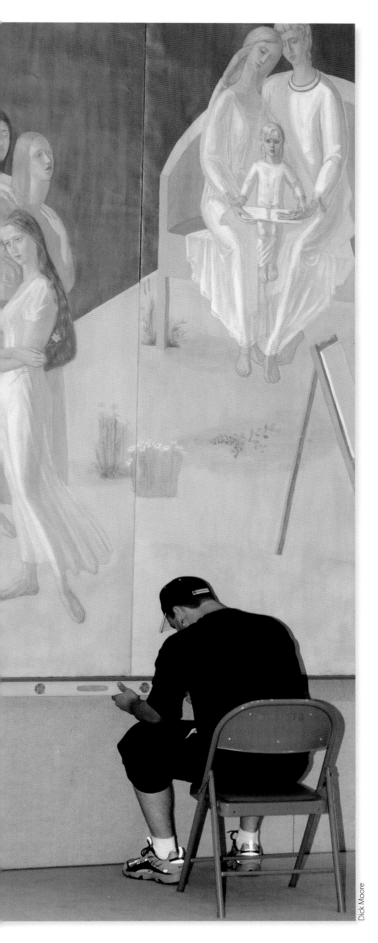

Dick Moore

Dick Moore

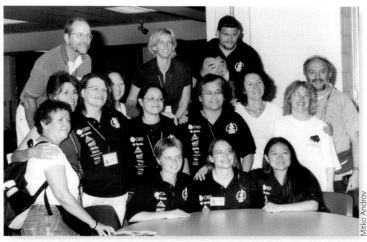

Mitko Androv

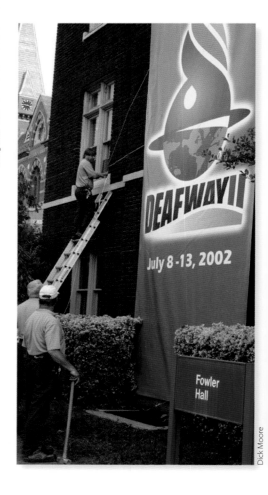

James Tabron, Lloyd Ballinger, Nebiyu Nega, and John Serrano unload goods from one of the many Deaf Way II supply trucks, top.

Volunteer Roy Ricci van der Stok (far right, above) leads a group of international visitors to their dorms.

Forty-foot-high banners hang from both Gallaudet's Fowler Hall building and the Washington Convention Center to welcome visitors to Deaf Way and to thank the sponsors.

Additional theater venues are set up in tents, above, at Gallaudet.

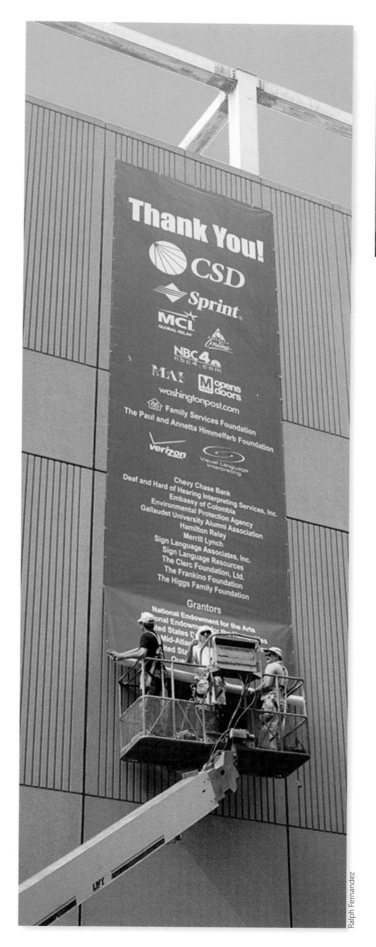

Thank You!

CSD

Sprint®

MCI
GLOBAL RELAY

AOL
Online

NBC4
nbc4.com

MAI

M opens
doors

washingtonpost.com

Family Services Foundation
The Paul and Annetta Himmelfarb Foundation

verizon

Visual Language
Interpreting

Chevy Chase Bank
Deaf and Hard of Hearing Interpreting Services, Inc.
Embassy of Colombia
Environmental Protection Agency
Gallaudet University Alumni Association
Hamilton Relay
Merrill Lynch
Sign Language Associates, Inc.
Sign Language Resources
The Clerc Foundation, Ltd.
The Frankino Foundation
The Higgs Family Foundation

Grantors
National Endowment for the Arts
ional Endowment for the Humanities
ted States D
Mid-Atlan
ted Sta
Que

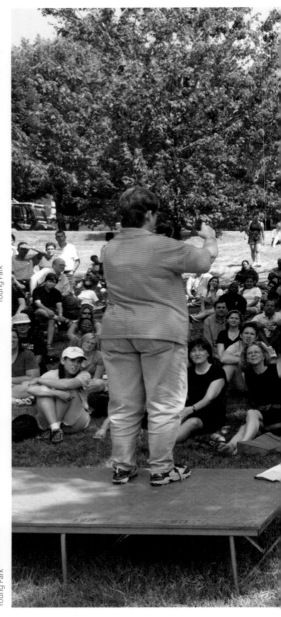

Young Park

Young Park

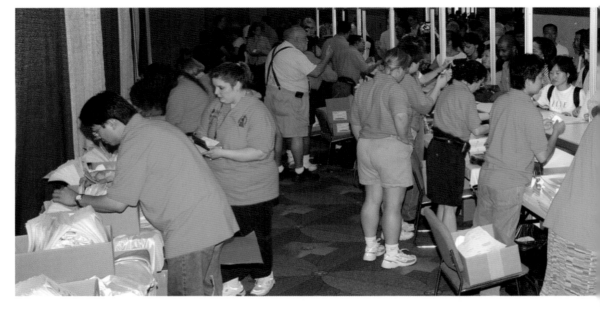

Deaf Way II volunteers were easy to spot in their bright orange shirts.

Dick Moore

Dick Moore

Dick Moore

Harvey Goodstein, right, chaired the Organizing Committee.

John Consoli

John Consoli

Committee members include (from left) Dwight Benedict, Cathy Sweet-Windham, and Zhou Fang.

Cultural Arts Coordinator Jay Innes, below, speaks with Paul Harrelson, the Associate Producer for the cultural arts events.

Dick Moore

Dick Moore

Ralph Fernandez

Young Park

Ralph Fernandez

Deaf Way II could not have been possible without the hard work of the many committee members and volunteers.

John Consoli

Todd Byrd

Dick Moore

Dick Moore

Dick Moore

John Consoli

Ralph Fernandez

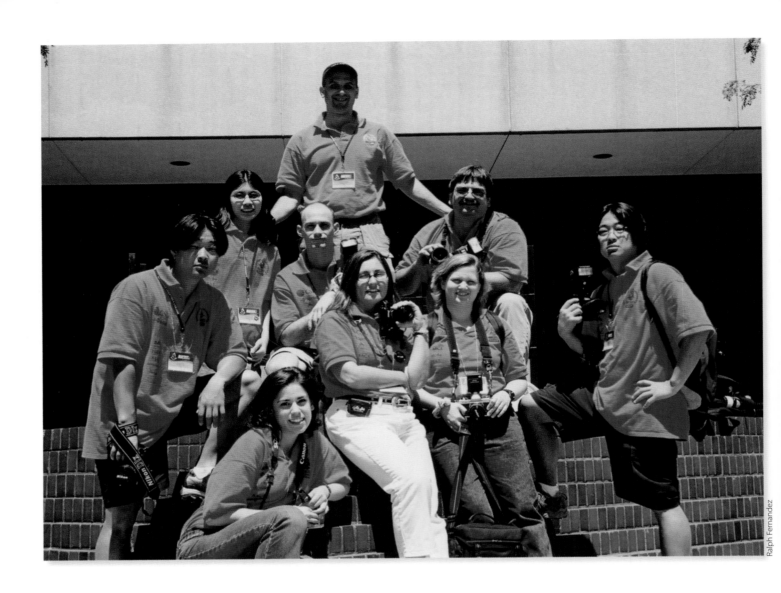

The official photography team, top,
poses for a picture of their own.

Ralph Fernandez

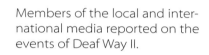

Members of the local and international media reported on the events of Deaf Way II.

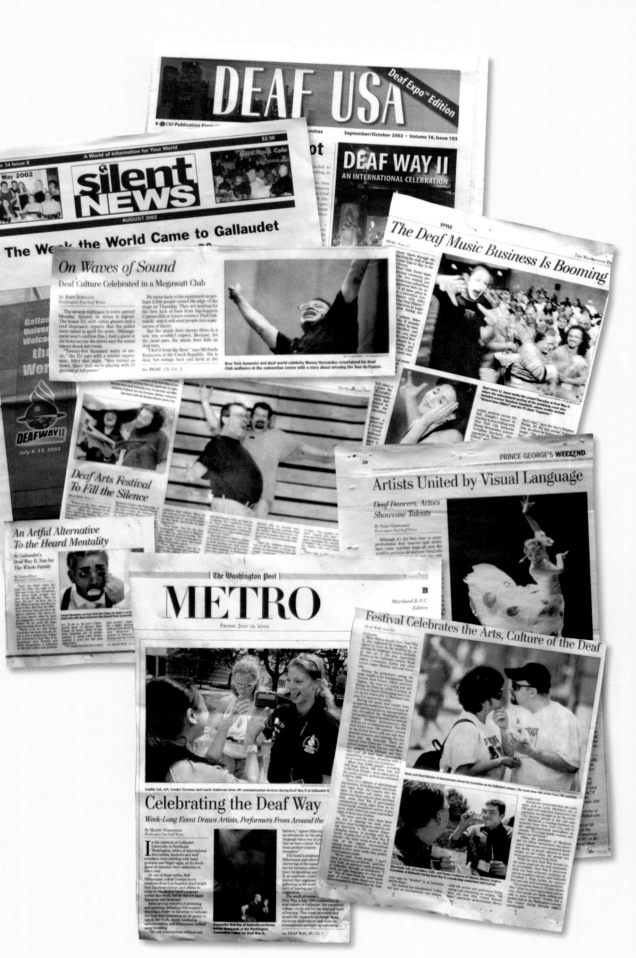

Zhou Fang

Zhou Fang

Deaf Way II Facts

Six-day conference
137-day arts festival
9,675 registered participants
121 countries represented
3,869 people from the United States
1,642 people from developing nations or economies
1,466 people from other countries
4,870 women
4,805 men
429 senior citizens
1,195 youth (26 and younger)
6,834 from North America
1,150 from Europe
825 from Asia
372 from Africa
314 from South America
74 from the Caribbean
59 from Oceania
47 from Central America
400,000 people attended performances or art exhibitions
54 country or regional representatives
500 volunteers
10,000 hours of volunteer service
11 committees
316 committee members
1,630 days (4.46 years) to plan
One goal
Immeasurable impact

Sponsors

Deaf Way II and Gallaudet University gratefully acknowledge the generous support of our sponsors, partners, grantors, and endorsers.

Title .. **CSD**

Presenting .. **Sprint**®

Platinum .. **AMERICA Online**

Gold ... **MCI GLOBAL RELAY** **NBC4 nbc4.com**

Silver ...

Lynn and Foster Friess Family Foundation

MAI **M metro opens doors**

washingtonpost.com

Bronze ...

AT&T **Family Services Foundation**

The Paul and Annetta Himmelfarb Foundation

Visual Language Interpreting

Friends of Deaf Way II

Chevy Chase Bank
Deaf and Hard of Hearing Interpreting Services, Inc.
Embassy of Colombia
Environmental Protection Agency
Gallaudet University Alumni Association
Hamilton Relay
Merrill Lynch
Sallie Mae
Sign Language Associates, Inc.
Sign Language Resources
The Clerc Foundation, Ltd.
The Frankino Foundation
The Higgs Family Foundation

Program Partners

American Association of Performing Arts Performers
Clarice Smith Performing Arts Center at Maryland
Embassy of Sweden
John F. Kennedy Center for the Performing Arts
Maryland National Capitol Park and Planning Commission-Cultural Heritage Division
Mexican Cultural Institute
Millennium Arts Center
National Arboretum
Smithsonian Institution
VSA arts

Grantors

Gallaudet University acknowledges support in part for the following Deaf Way II special projects from the National Endowment for the Arts and the National Endowment for the Humanities:

The awards are as follows:

Dr. Dirksen Bauman
National Endowment for the Humanities Focus Grant
"Deaf Think Tank"

Dr. Jay Innes
National Endowment for the Humanities
"The Role of Deaf Art in Defining Deaf Culture"

Dr. Jay Innes
National Endowment for the Arts
"Leadership Initiatives AccessAbility/Research"

Dr. Jay Innes
National Endowment for the Arts
"Support for Deaf Way II Artists"

Mr. Willy Conley
U.S. Department of Education
Quest: arts for everyone
"Theatre Bridge"

The Visiting Artist Program
Mid-Atlantic Arts Foundation
Quest: arts for everyone

Many deaf organizations around the world have wholeheartedly endorsed Deaf Way II. They include:

World Federation of the Deaf

National Association of the Deaf, USA

The World Federation of the Deaf (WFD) is the international non-governmental organization representing deaf people worldwide. A non-profit organization, WFD works for human rights and equal opportunity for deaf people everywhere. WFD promotes the right of deaf people to use sign language to access education, information, and all other spheres of life. In this way will deaf people achieve equality and human rights.

The National Association of the Deaf (NAD), established in 1880, is the oldest and largest constituency organization safeguarding the accessibility and civil rights of 28 million deaf and hard of hearing Americans in education, employment, health care, and telecommunications. A private, non-profit organization, the NAD is a dynamic federation of 51 state association affiliates including the District of Columbia, organizational affiliates, and direct members.

Committees

Deaf Way Organizing Committee (DWOC)
Harvey Goodstein, Chair
Dwight Benedict, Vice Chair–Operations
Rosanne Bangura, International Coordinator
John Lewis, Coordinator of International Affairs
Laura Brown, Program Assistant
Cathy Sweet-Windham, Coordinator of Sponsorship Programs/Philanthropic Support

Advertising Committee
Vladimir Kotenev, Coordinator

Low Cost Housing Committee
Thelma Schroeder, Coordinator
Matilda Lonn, Assistant

Marketing Committee
Roz Prickett, Coordinator
Mercy Coogan, Public Relations Liaison
Michael Kaika
Darlene Prickett
Ralph Fernandez
David Tossman
Todd Byrd
Shondra Dickson
Dawn Bradley
Zhou Fang
Donna Thomas

Merchandise Committee
Astrid Goodstein, Coordinator
Priscilla O'Donnell
Debra Lawson
Zhou Fang

Technology Committee
Lloyd Ballinger, Co-coordinator
Jeff Murray, Co-coordinator
Jim Dellon
Patrick Harris
Ron Reed
Sandy White
Mike Cooper
Wally Barretto, Kiosk/Café Computer Management
Chuck Bowie, Kiosk/Café Computer Management
Jeffrey Whittaker, Kiosk/Café Computer Management
Peter Un, Systems and Engineering/Networks Administration
Bill Millios, Computer Science Instruction
Zhou Fang, Web/DB Applications Designer
Ralph Fernandez, Web/DB Applications Designer
Hatim Vali, Web/DB Applications Designer

Volunteer Committee
Mary Anne Pugin, Coordinator
Helena Schmitt, Assistant to the Coordinator

Youth Programs Committee
Dwight Benedict, Supervisor
Matilda Lonn, Manager
Elisha Robinson, Manager
Debby DeStefano, Coordinator, Ages 13–17
Jimmy DeStefano, Coordinator, Ages 13–17, DWII Sports Camp
Darian Burwell, Group Leader, Ages 13–17
Ricky Suiter, Group Coordinator, Ages 9–12 and Ages 6-8
Clifford Geffen, Group Leader, Ages 9–12
Carnia Hed-Edington, Group Leader, Ages 9–12
Rosemary Balzer, Group Leader, Ages 6–8
Gail Solit, Coordinator, Ages 2–5
Mary Lott, Coordinator of Kid's Club
Rebecca Goldenbaum, Assistant Coordinator of Kid's Club

Liaisons
Stan Matelski, Sponsored Programs Liaison
Fred Kendrick, Business & Auxiliary Services Liaison
Robert Mobley, Center for Global Education Liaison
Sharon Hayes, Center for Global Education Liaison

Conference Committee
Mike Kemp, Coordinator
Laura Brown, Assistant to the Coordinator

Advocacy & Community Development
Cheryl Heppner
Pamela Holmes
Robert Roth
Claude Stout
Judith Viera

Economics
Emilia Chukwuma
Steve Chaikind
Pat Johanson
Isaac Agboola

Education
Judith L. Johnson
Cynthia N. Bailes
Rae Johnson
Simon Guteng

Family
Barbara White
Martha Sheridan

Pat Spencer
Scott Bally
Linda Lytle
Janet Pray
Judy Mounty

Health/Mental Health
Jeff Lewis
Barbara Brauer
Diane Morton

History
Joe Kinner
Susan Burch
Steven Weiner

Language & Culture
Dirksen Bauman
Kristen Harmon
Ben Bahan
Genie Gertz
Jennifer Nelson

Literature
Dirksen Bauman
Kristen Harmon
Ben Bahan
Lynn Jacobowitz
Jennifer Nelson

Recreation, Leisure & Sports
Gina Oliva
Robby Carmichael
Sarah Doleac
Sandy McLennon
Andy Brinks

Sign Language & Interpretation Issues
MJ Bienvenu
Carlene Prezioso

Technology
Judy Harkins
Gunnar Hellstrom
Carl Jensema
Cynthia King
William Millios
Claude Stout
Judith Viera
Norman Williams

Youth
Jennifer Yost
Dan Brubaker

Cultural Arts Committee
Jay Innes, Cultural Arts Coordinator
Tim McCarty, Producer
Paul Harrelson, Associate Producer

Renee Decker, Assistant to the Producer
Paulina Wlostowski, Production and Publication Assistant
Lijiao Huang, Cultural Arts Assistant

Performing Arts
Fred Noel, Senior Production Manager
Kevin Dyels, Production Manager
Betsy Meynardie, Liaison Coordinator
Leslie Page, House Management Coordinator
Iosif Schneiderman, Opening Celebration Director
Myra Coffield, Opening Celebration Stage Manager and Production Liaison
Lois Bragg, DVD Producer
Ann Wroth, Group Sales Coordinator
Teresa Ezzell, Festival Assistant
Matt Goedecke, Production Liaison
Sue Jacoby, Production Liaison
Jon Wolfe Nelson, Production Liaison
Tina Dunams, Production Assistant
Kelley Duran, Production Assistant
Sula Gleeson, Production Assistant
Eliza Greenwood, Production Assistant
Elana Nightingale, Production Assistant
Annie Wiegand, Production Assistant
Rye Zemelsky, Production Assistant

Visual Arts
Peggy Reichard, Coordinator
Chuck Baird, Co-Curator and Artist in Residence
Laura Kim, Curatorial Assistant
Mary Thornley, Visual Arts Program Editor
Linda Jordan, Editor and Consultant
Susan Flanigan, Art Tour Coordinator and Promotions
Mary Silvestri, Docent and Artist Activities Coordinator
Trace Salaway, Technical Production Consultant
Sander Blondeel, Artist in Residence
Ingrid Crepeau, Artist in Residence
Abelardo Parra Jimenez, Artist in Residence
Ron Hill, Spring Intern
Lisa Ambrose, Spring/Summer Intern
Liza deLumeau, Spring/Summer Intern
Amanda Hilleque, Spring Intern
Shelby Xiao Jia, Spring/Summer Intern
Melissa Kononenko, Spring Intern
Marlene Lankenau, Spring/Summer Intern
Sabrina Lankenau, Spring/Summer Intern
MaryJane Luakian, Spring/Summer Intern
Joy Maisel, Spring Intern
Krista Nasser, Spring/Summer Intern
Roy Ricci van der Stok, Spring/Summer Intern
Ping Wang, Spring/Summer Intern
Troy Towers, Summer Intern
Leigh Landon, Summer Intern
Solenn Terrom, Summer Intern
Sue Baldi-Fields, Summer Intern
Patrick Clifford, Summer Intern

Literary Arts
Tonya Stremlau, Coordinator and Anthology Editor
Bruce White, Local Arrangements Committee Member
Erin Whitney, Local Arrangements Committee Member
Jacquelyn Girard, Local Arrangements Committee Member
Jake Temby, Local Arrangements Committee Member
Ivey Wallace, Gallaudet University Press
Pia Seagrave, Literary Arts Consultant

Storytelling Committee
Benjamin Bahan
Patricia Yates
Frank Bechter
Maureen Burns, Liaison Coordinator

Film and Video Committee
Jane Norman, Faculty Coordinator
Slava Klimov, Student Liaison Coordinator
Jeff Whitaker, Technical Coordinator
Anders Johansson, Liaison Coordinator
Andrew Ludka, Liaison Coordinator

Workshops and Master Classes
Angela V. Farrand, Coordinator
Laurie Anderson, Cultural Arts Intern
Paul Dymoke, Cultural Arts Intern
Jamie Recht, Workshop Assistant
Fina Perez, Workshop Assistant

International Deaf Club Entertainment
Sherry Duhon, Coordinator
Joi Holsapple
Frank Bechter

Featured Artists Hospitality Committee
Debby Destefano, Coordinator
Ruth Innes
John Levesque
Doreen Moore
Richard Moore
Paul Stefurak
Renee Suiter
Brenda Tress-Mowl

Interpreting Committee
Jan DeLap, Director
Diana Markel, Co-coordinator
Juniper Sussman, Co-coordinator
Anne Acampora, Program Assistant

DeafBlind Team
Rhonda Jacobs, Team Leader
Liz Scully, Assistant Team Leader
Steven Collins, Assistant Team Leader/Support Service Provider Coordinator

Amy Nelson, Assistant SSP Coordinator
ASL-English Interpreting Team
Mary Darragh MacLean, Team Leader
Lewis Merkin, Assistant Team Leader
International Sign Interpreting Team
Juniper Sussman, Team Leader
Anne Acampora, Assistant Team Leader
Jan DeLap, Assistant Team Leader

Interpreter Support Team
Kim Pudans-Smith, Team Leader
Beth Graham, Assistant Team Leader

World Sign Language Team
Sarah Rauber, Team Leader

Media and Sponsored Events
Brandon Arthur, Team Leader
Anne Leahy, Assistant Team Leader

Logistics
Kim Pudans-Smith

Hospitality
Kim Pudans-Smith
Amy Markel, Chair
Phi Kappa Zeta Alumni Sisters

Advisor
Steve Walker

Volunteer Liaison
Jennifer Wagner

Interpreting Committee Volunteers
Janie Golightly
Pam Markel
Steve Moore
Carol Moore
Ann Cole
Steven Cole
Angel Smith
Joe Smith
Abbey Roin
Lee Smith
Allen Markel
Barbara Brinks
Susan Chin
Zdenka Rompf
Chester Virnig
Heather Christensen
Eddie Martinez
Student Volunteers
Michelle Clapp
Julie Moffitt
Crystal Bradley

Cultural Arts Liaisons
Andrea Capuyan
Sherry Hicks

International Sign Summer Training
Steve Walker
Jemina Napier
Carolyn Ressler
MJ Bienvenu

Operations Committee
Dwight Benedict, Vice-Chair of Operations
Travis Imel, Special Assistant
Vicki Sealock, Special Assistant
John Serrano, Special Assistant
Matilda Lonn, Manager of Disability Issues
Arthur Roehrig, Disability Issues
Susan Hanrahan, Housing Coordinator
Travis Imel, Assistant Housing Coordinator
Thomas Koch, International Deaf Club Coordinator
Brenda Keller, Meal Plan Coordinator
Heather Foster, Assistant Meal Plan Coordinator
Allen Talbert, Coordinator of Workshop Session Committee
Beth Benedict, Area Coordinator
Dale Ford, Area Coordinator
Frank Turk, Jr., Area Coordinator
Transportation Coordinator

Registration Committee
Laura Brown, Co-Coordinator
Anjali Desai-Margolin Co-Coordinator
Deb Barron
Pamela Mower
Murray Margolin
Emilio Insolera
Gilbert Lensbower
Shannon Lally
Barbara McNally
Kelly Clayton

International Countries and Regional Representatives
Victor Abbou
Benjamin Akinbobola
Nazar Al-Gumer
Florea Barbu
Anna Bernatek
Manzoor Bilal
Kristinn Jon Bjarnason
Anna Cernic
Rajeswari Chandramohan
Fanny Yeh Corderoy du Tiers
Henri Corderoy du Tiers
Paulo Jorge da Silva Costa
Monika Dabrowska
Peter Dumbuya
Laurie Elbieh
Serry Fahmy
Cristina Freire

Constantinos Gargalis
Henryk Glicner
Stefan Goldschmidt
Ludovico Graziani
Elvia Guillermo
Michael Hefty
Emilio Insolera
Robert Janiszewski
Slavica Jelic
Vladmir Kotenev
Przemyslaw Krezel
Bernard le Maire
Feliciano Sola Limia
Jennifer Lynch
Ramesh Mirchandani
Sibilia Munoz
Rumiko Nozaki
Benjamin Nzyuko
Joni Oyserman
Iveta Pavlovicova
Eugenio Ravelo-Mendoza
Dmitry Rebrov
Julie Rees
Donald Shelton
Beata Slowikowska
Ahmed Taqawi
Jonas Torboli
Danilo Torres
Franklin Torres
Anna Roslaug Valdimarsdottir
Madan Vasishta
Filip Verstraete
Lisa Vogel
Gunilla Wagstrom Lundqvist
Beata Wawrzyniak
Satu Worseck
Rodrigo Zapata

Developing Nations Support Service (DNSS) Committee
Coordinators
Senda Benaissa
Charles Reilly
Peck Choo-Kim

Language Translation team
Mark Weinberg
Pilar Pinar
Yasunori Akishima
Mohammad Obiedat
Maggie Madeo

International Sign Language team
Steven Walker
Silvia Lemmo
Rakesh Taneja
Karunya Samuel
Monica Har

Design team
Linda Tom
Hongyou Xu
Maria T. Guzman
May Talhouk
Lisa Ambrose
Amanda Hilleque
Joy Maisel

Committee
Ramesh Mirchandani
Beng Lam
Minar Kamdar
Chuck Hom
Megan Youngs
Shilpa Hamumntha
Larisa Aranbayeva
Amy Wilson

Thanks and Acknowledgments:

The Deaf Way II Organizing Committee would like to thank all of the thousands of volunteers who have devoted their time and energy into making Deaf Way II and the Cultural Arts Festival a huge success. Without their support we could not have put together the biggest gathering of the Deaf community ever! While we have tried to identify each and every person who should be acknowledged, invariably some unsung heroes will go unnamed. Though a name may not be listed, their contributions are very much appreciated!

Thank You!

CSD

Sprint

MCI GLOBAL RELAY **Online**

NBC4
nbc4.com

MAI **M opens doors**

washingtonpost.com

Family Services Foundation
The Paul and Annetta Himmelfarb Foundation

verizon **Visual Language Interpreting**

Chevy Chase Bank
Deaf and Hard of Hearing Interpreting Services, Inc.
Embassy of Colombia
Environmental Protection Agency
Gallaudet University Alumni Association
Hamilton Relay
Merrill Lynch
Sign Language Associates, Inc.
Sign Language Resources
The Clerc Foundation, Ltd.
The Frankino Foundation
The Higgs Family Foundation

Grantors

National Endowment for the Arts
National Endowment for the Humanities
United States Department of Education
Mid-Atlantic Arts Foundation
United States Department of State
Quest:arts for everyone

Program Partners

Clarice Smith Performing Arts Center at Maryland
Embassy of Sweden
John F. Kennedy Center for the Performing Arts
Maryland-National Capital Park and Planning
Commission-Cultural Heritage Division
Mexican Cultural Institute
Millennium Arts Center
National Arboretum
Smithsonian Institution
VSA arts